1977

BRUSHWORK

BRUSHWORK

A GUIDE TO
EXPRESSIVE BRUSHWORK
FOR OIL PAINTING

BY EMILE A. GRUPPÉ
EDITED BY CHARLES MOVALLI

WATSON-GUPTILL PUBLICATIONS/NEW YORK
PITMAN PUBLISHING/LONDON

Copyright© 1977 by Watson-Guptill Publications

First published in 1977 in the United States and Canada by Watson-Guptill Publications,
a division of Billboard Publications, Inc.
1515 Broadway, New York, New York 10036

Library of Congress Cataloging in Publication Data
Gruppé, Emile A 1896-
 Brushwork.
 Bibliography: p.
 Includes index.
 1. Brushwork. 2. Painting—Technique.
I. Title.
ND1505.G78 751.4 76-30892
ISBN 0-8230-0525-9

Published in Great Britain by Pitman Publishing, Ltd.
39 Parker Street, London WC2B 5PB
ISBN 0-273-01047-6

Manufactured in U.S.A.

First printing, 1977

I dedicate this book
to my wife, Dorothy,
and to my two children,
Robert and Emily.

ACKNOWLEDGMENTS

I would like to thank Don Holden,
who originated the idea for this book,
and Charles Movalli, who photographed
and organized it.

CONTENTS

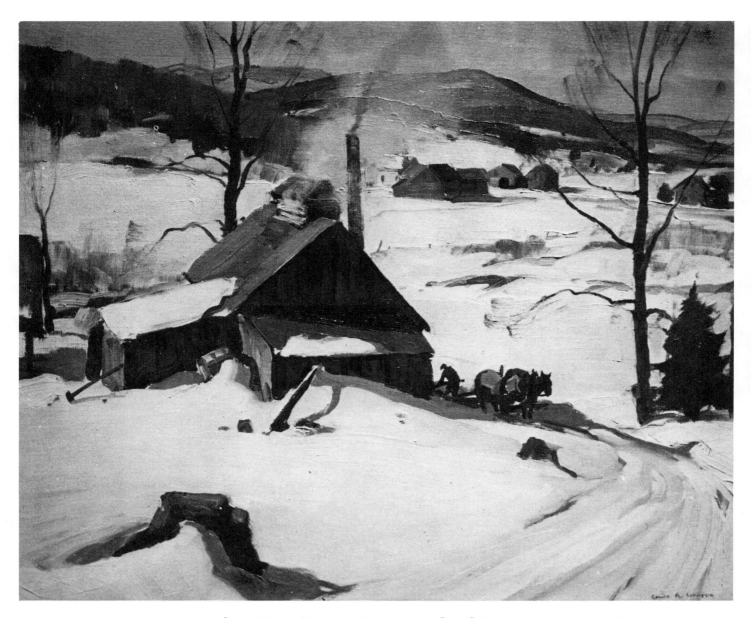

Sugar House, Vermont, *oil on canvas, 30" x 36" (76 x 91 cm.). The owner of this sugar house sold his maples for timber, leaving only a few saplings to take the place of the larger trees. I painted the picture toward the middle of the day. The sun eliminates most of the shadows on the snow — so the whole mass is painted with a few very large brushstrokes. The dark trees and buildings stand out sharply against this expanse of white. I contrasted the sizes of objects in the picture to give a feeling of perspective. There's a big stump in the foreground, while a similar stump looks much smaller in the distance. The foreground building is large, but the background farms are small. The pine to the far right is large, and directly above it a background pine is suggested by one quick stroke. The small horse and man give scale to their surroundings — they provide a standard by which you can gauge the size of everything.*

INTRODUCTION

We all know that mood and design are what count in a painting—so why are brushstrokes important? They're just a part of a painter's technique, aren't they? Yet whenever I look at a student's work, the first thing I search for is a unity of technique. I know many teachers recommend that their students paint each picture differently—that they experiment. And I've known students who paint landscapes in one style (a style like that of some popular painter), flowers in a different style, and portraits in yet another style. This urge to experiment is good—I experimented a lot when I was just starting out. But after a point, you begin to wonder when the painter is going to make up his mind. Who *is* he anyway? What is his point of view? When will he begin to speak in his own voice? So technique and *brushstrokes* are important as an expression of the artist's personality.

In addition, there's a very practical value to the brushstroke. Outdoor painters have to work fast. An effect rarely lasts more than three hours—often not even that long! So we need a technique that records facts quickly and concisely. Years ago, I was up in Vermont with one of my old instructors. We stopped along a road at sunset, but he didn't want to paint. He thought it was too late and too cold. So I jumped out and painted a quick canvas, 25" x 30" (64 x 76 cm.). I can still remember him slapping his head as I came back to the car and turned the picture towards him. "You don't paint pictures," he said, "you write them—each stroke is descriptive!"

I've always tried to find the stroke that best describes what I feel about a particular subject. Of course, this isn't the only way to paint. Some people like to smooth their strokes out, while others use strokes in a decorative way. The same curved stroke, for example, will run through rocks, trees, and clouds. But when you use strokes arbitrarily, you're in danger of becoming a mannerist. People pay more attention to *how* you say a thing than to *what* you're saying!

I want to communicate quickly and directly to the viewer. That's why I recommend broad and simple painting. The direct approach lets you tell your story with a minimum of digressions. In addition, each stroke has to say something about your subject; you're forced to look closely. *Look twice and paint once!* Study the subject, then figure out where you want to place it on your canvas. Look a second time, checking again for its characteristic angles and curves. And then make your stroke. By that time, you should know what you're doing.

SHAPE AND VALUE

People always ask me how I can paint so broadly—yet still know that the picture will look "realistic" from a distance. There isn't any mystery. As I work, I try to get the general shape of the object and, more importantly, its correct value (its lightness or darkness—how it would look if I took a black-and-white photo of it). If you get the values right, almost anything will look good from a few feet back.

Squint when you work outdoors—that pulls shapes together and

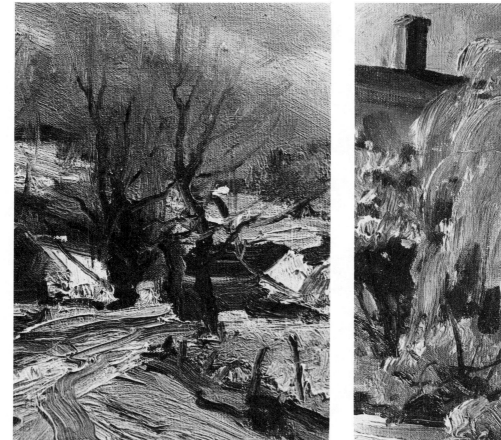

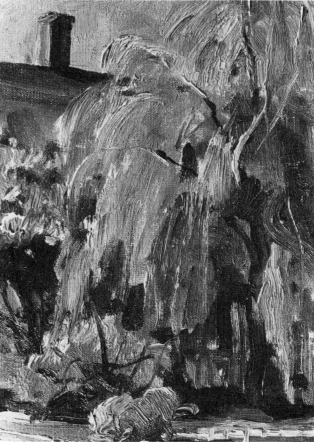

Maples: Detail (*above*). *Angular, broken strokes suggest the character of a group of maples.*

Willow: Detail (*above right*). *Drooping, light strokes suggest the feathery foliage of the weeping willow.*

Large Rock: Detail (*right*). *Short, thin strokes convey the rifts in a large rock.*

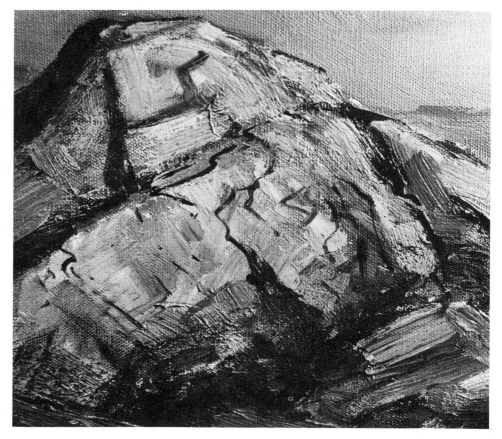

simplifies values. Don't keep your eyes wide open all the time—like the people from Missouri who have to be shown everything. Look for the big pattern and paint it as simply as possible. Don't count strokes; but remember that one stroke states an idea more clearly than four or five. Multiple strokes blunt your point, and the picture becomes like a story with too many words in it. That's why Charles Hawthorne made his students paint with palette knives. They had to go for the big statement, for the principal shape and value relationships—without worrying about the unimportant details.

Since I've discussed values at length in a previous book, I won't go into the subject here. You can look at the illustrations and study the value relationships for yourself. Notice how the darkest darks are always in the foreground and things become lighter as they move into the distance. Notice also how light a dark object can be in sunlight, and how dark a light object is in shadow. Hawthorne stressed that objects in light should pertain to the light—and those in shadow should pertain to the shadow.

BRUSHES AND CANVAS

I recommend large brushes. Get plenty of sizes 12, 10, and 7. Have just one small brush for painting details such as small branches and cracks in a rock. I once worked exclusively with a palette knife, but I don't anymore. I can't get movement with it, and the knife isn't suited to recording subtle transitions and soft edges.

Don't cradle a brush in your hand like a pencil, holding it tightly near the bristle! The handle of the brush should rest along the inside of your hand, with the thumb holding it against the other fingers. That allows you to use your whole arm when painting. As you gain in experience, you'll discover "special" grips that make certain kinds of strokes easier to paint. I draw masts, for example, by holding the very end of the brush between my thumb and forefinger. I place the brush at the top of the canvas and let it drop of its own accord. The brush does the work. When I paint the small branches of a tree, I hold the brush the same way, twisting it slightly as the branch emerges from the trunk. The twisting brush takes a slightly erratic course—just right for the broken movement of the branches. As I get to the very end of the branch, I flip the brush off the canvas, drawing the line to a fine point. Such facility comes naturally—so don't worry about it.

Try starting with canvases 16" x 20" (41 x 51 cm.). The size is small enough to be manageable—yet big enough to require a certain broadness of approach. Occasionally experiment with bigger canvases, too. I always feel much freer when I work on a canvas 25" x 30" (64 x 76 cm.) or 30" x 36" (76 x 91 cm.). There's room to swing your arm. On a small surface, your stroke may be only half an inch long and your hand trembles as you make it. On a large canvas the same stroke covers a couple of inches. You paint it with your whole body—not just with your wrist.

PIGMENT AND MEDIUM

I use a lot of painting medium, particularly when I'm starting and want to fill the tooth of the canvas. I believe in using paint—in painting like a millionaire. Put a lot of color down and shove it around till it looks

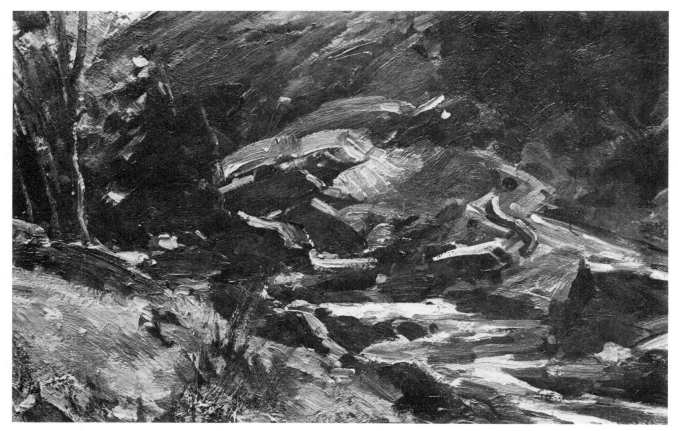

Many Rocks: Detail. *Short, angular strokes suggest the edges and sides of rocks.*

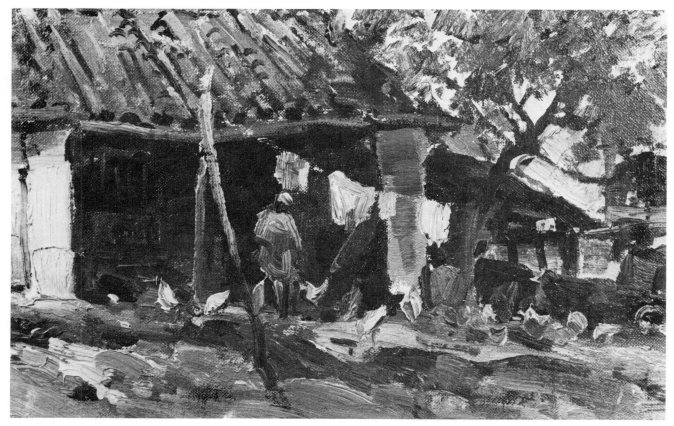

Barnyard: Detail. *A variety of strokes correspond to the different textures of a barnyard.*

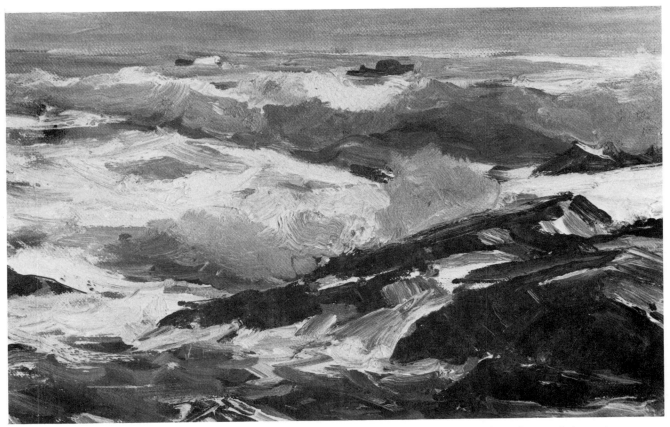

Rocks and Water: Detail. *The hard edge of the rock contrasts with and emphasizes the softness of the water.*

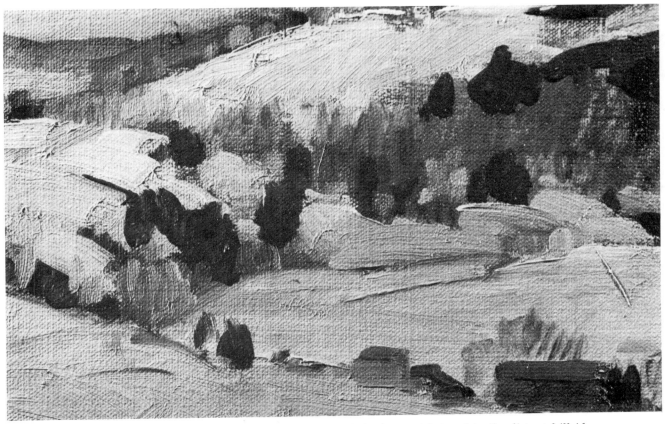

Hill with Evergreens: Detail. *Dark strokes (evergreens) add rhythm and interest to the distant hillside.*

Leaves and Branches: Detail. *Rounded strokes (leaves) connect the branches of the tree and create a visually exciting pattern.*

Hill and Buildings: Detail. *The heavily painted hill and buildings contrast to the more thinly painted sky.*

Near and Far Rocks: Detail. *We see the textures of nearby rocks; those farther back are more flatly painted.*

right. The paint acts as a lubricant. Let's say you're painting a thin, dark branch against a light sky. The brush glides over a wet, well-covered canvas—but it sticks and moves jerkily over a stained, half-dry one.

Stained areas also look flat and lifeless. However, you can use them effectively when painting shadows, since they make the shadow look transparent. But in the highlights I like to "load" the paint, to put it on heavily (this is also called painting with "impasto"). Even when you use the same color, a stained highlight won't register as well as a loaded one. The thickness of paint catches the eye. Since the sun is the source of light, I also like to use a volume of paint in my skies. I may smooth the paint down (on a foggy day) or leave it fairly rough (if I'm looking toward a brilliant sun)—but I make sure the paint covers the canvas. A stained sky looks weak and has no solidity to it.

USES OF STROKES

I don't want to talk too much about the uses of strokes here — we'll spend the rest of the book studying them. But I can summarize the ways strokes function in a painting. Some of the closeups illustrating these functions will probably look very abstract to you. When I refer to an especially loose one, look at it and try to sense the fun I had as I made each stroke. Much of the joy of painting isn't in matching colors —it's in the actual handling of the paint, playing a thick area against a stained one, a wide stroke against a thin one, a curving line against an angular one. Remember: you're a *painter* and should get pleasure out of the use of your materials.

1. Form. The most obvious use of a stroke is to describe the form of an object. In the detail of maple trees (page 10) a couple of jerky, twisting, broken strokes are used to suggest the character of old, gnarled maples. In the detail of a large rock (page 10) a broadly painted surface is broken by similar angular strokes — this time they suggest the cracks and chips in a large boulder.

2. Texture. Strokes are related to the textures of objects. The detail of the willow tree (page 10) shows the foliage of a weeping willow — the strokes droop downward, staining the canvas and suggesting the feathery character of the material. Hard, angular, with clearly defined sides and edges, the rocks in the detail of many rocks (page 12) have a completely different texture. The detail of a barnyard (page 12) is a conglomeration of strokes: dots for chickens, larger strokes for hanging clothes, squiggles for leaves on the tree, and horizontal strokes for the flat land.

3. Contrast. By contrasting one kind of stroke against another, you emphasize the unique character of each. In the detail of rocks and water (page 13), for example, the edges of the rocks are all hard and straight. The breaking surf is rhythmic—with some edges almost disappearing into the glare of the background water. The hardness of one stroke accentuates the softness of the other.

4. Patterns. Strokes can make an area interesting by giving it an arresting design. In the detail of a hill with evergreens (page 13) dark dots (evergreens) break a distant hillside into an exciting staccato rhythm. In

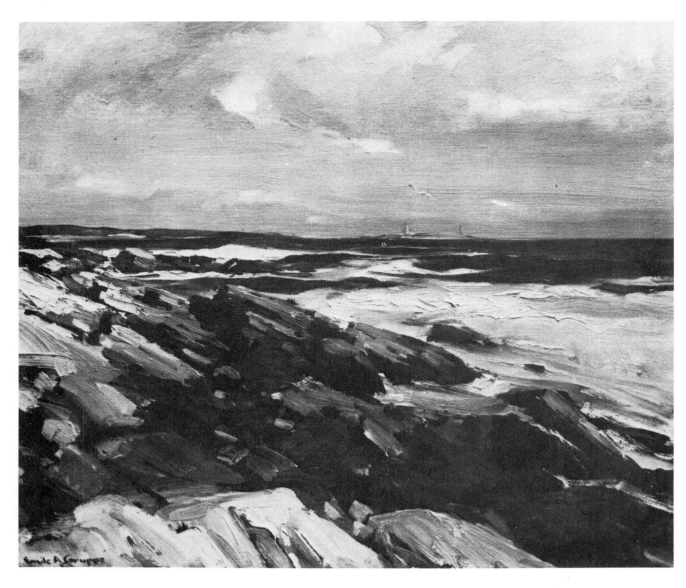

Rocks and Surf *(above), oil on canvas, 25" x 30" (64 x 76 cm.). Wide strokes suggest foreground rocks; thinner strokes, the shapes in the distance.*

Sycamore Tree: Detail *(right). Light and dark strokes should be placed so that they emphasize one another.*

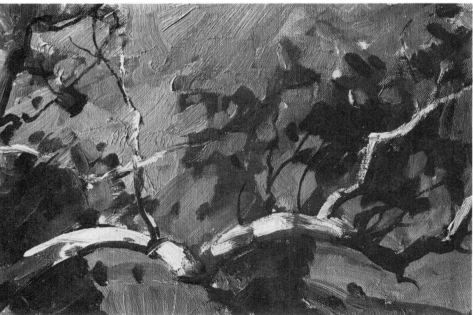

the detail of leaves and branches (page 14), rounded bunches of leaves connect the branches of the tree and break the light background into a variety of different and interesting shapes.

5. *Thickness.* Strokes also suggest the position of an object in space. In the detail of near and far rocks (page 14) the rocks in the center of the picture are near us and are painted with a heavy impasto. The rocks behind them have a less visible texture. In the detail of hill and buildings (page 14) the hill is heavily painted, while the trees, farther in the distance, are more thinly handled. You can see the tooth of the canvas through them. The sky is even more flatly painted.

6. *Width.* The size of the stroke can also help the viewer determine the object's position. In *Rocks and Surf* (page 16), for example, the foreground rocks are painted with a few wide strokes. Further back the strokes become smaller—and the distant headland is just one long, thin stroke. (Notice also that the shadow areas become lighter in value as they recede.)

7. *Value.* Light and dark strokes can be used to accent one another. In the detail of a sycamore tree (page 16) the light, peeled part of the sycamore branch would disappear if it were brought up against the light sky—so I placed a cluster of dark leaves to either side of it. Similarly, the dark, unpeeled part of the branch is placed against the light sky. I know this sounds obvious. But you'd be surprised by the number of students who put light figures against light buildings — and then wonder why the figures don't stand out!

8. *Direction.* Strokes naturally have a direction—they begin someplace and end someplace. Use this movement to direct the eye of the viewer through your picture. In *Frozen Stream, Vermont* (page 18) individual strokes describe the dark areas along the river bank. These strokes point you around the bank and into the picture. The thin, dark strokes along the edges of the ice zig-zag you in the same direction.

9. *Opposition.* We contrasted the textures of different strokes; we can also counterpoint their movement. In *Morning Light* (page 18) the strokes of the background rocks and white water move diagonally from upper left to lower right. The strokes that make up the large foreground rock move in the opposite direction, emphasizing by contrast the downward crash of the wave. (Cover the foreground rock and see how static the picture suddenly becomes.)

10. *Density.* Although strokes can be exciting, it's easy to have too much of a good thing. Years ago I was rejected from a particular show — something that had never happened before—and I was puzzled. I went out painting with a friend and asked him what he thought I was doing wrong. Fortunately, he was painting murals at the time and was preoccupied with their special problems: you can't clutter a mural and expect people forty feet away to understand it. He was primed for my question and told me my paintings had too much in them. I was describing everything—and didn't leave the viewer any "breathing spaces." In one of the best single lessons I ever had, he took my brush and simplified large areas of the canvas by pulling the strokes together. That's when I

Frozen Stream, Vermont *(right), oil on canvas, 30" x 36" (76 x 91 cm.). The dark strokes along the river bank point you into the design.*

Morning Light *(below), oil on canvas, 24" x 36" (61 x 91 cm.). The foreground rock emphasizes the crashing surf by moving in a contrasting direction.*

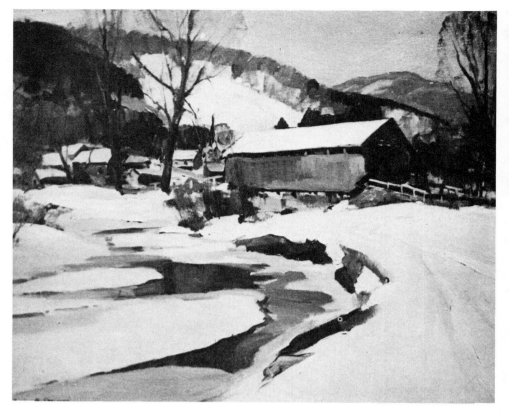

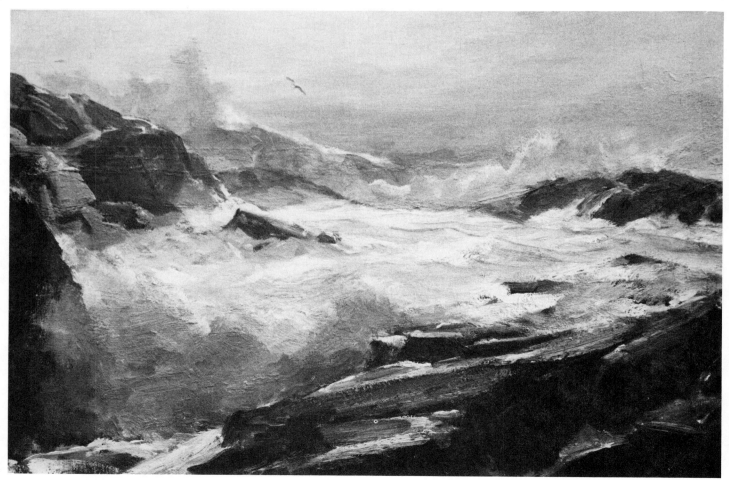

learned the value of reserve in art. You can have a lot of active brush-work around your center of interest — but have quiet spots where the viewer can go for relief.

FINISH

When is a painting finished? My instructor claimed that his studio paintings were more "profound" than his sketches because he put more of himself in them. But I still liked the fresh, personal, outdoor studies that were the basis of his indoor work. The studies were full of accidental effects. One stroke, for example, would suggest a stream. But in enlarging the composition to a canvas 40" x 50" (102 x 127 cm.) he'd make that stroke into ripples, a bank, and rocks along the shore. It became specific: a thing rather than a suggestion.

Students often think that perfection is the greatest art. They want their money's worth — the picture has to tell everything. But who can draw the perfection of nature? If you really want perfection, you could spend your whole life on one picture. You'd never get every detail; there'd always be more to do. From that point of view, it doesn't matter if you stop halfway to perfection (as even the most accomplished draftsman does) or a quarter of the way. I stop when I've said what I want to say. What counts is the statement. When I go into a gallery, I don't look at the details. I want the pictures to *do* something to me. I want to *feel* what the painter felt. If everything is hard and cold, I move on. I might as well be looking at a photograph.

CONCLUSION

Don't let my ideas get in the way of your personal development. Just use what makes sense to you. I plan to stick to the most fundamental of relationships: the relationship between the individual stroke and the things described. The organization of the book is, accordingly, very simple. Each chapter covers a different subject and is illustrated by complete paintings and appropriate details. It's as if you were at a gallery. You see the picture first and then step up to take a closer look—to see "how the painter did it." Occasionally a full-page picture is inserted as a change of pace; it gives me a chance to talk about more general topics. I don't want to spend all my time cataloguing strokes—if I did that, we'd both soon be fast asleep!

How I paint a branch, leaf, or reflection is personal to me. But in showing you the thinking *behind* the stroke, I hope to give you some food for thought. Remember: when you paint "loosely," you're not just throwing paint on the canvas, hoping it will land in the right spot. Each time you make a stroke, you have to think; you have to know exactly what you want to say. Of course, there's also a lot of fun in impressionistic painting. And as you try to capture the significant facts of nature, you'll find that you greatly increase your knowledge and appreciation of the world. You learn to look with a sharper eye. You ask questions and draw conclusions. You don't guess any more — you paint what you know!

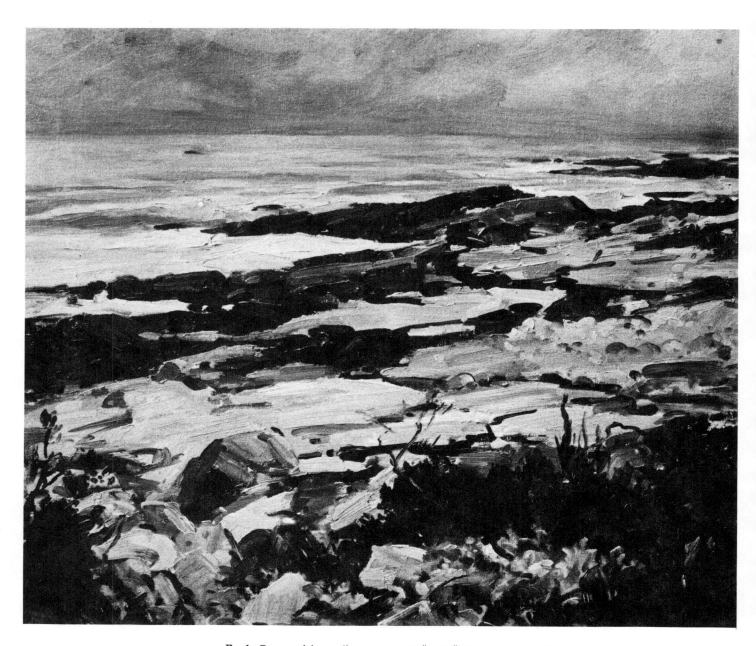

Rock Composition, *oil on canvas, 25" x 30" (64 x 76 cm.). This is clearly a picture of rocks. Although there's lots of activity in the design—swirling strokes for the foreground brush, dots and dashes for the boulders and smaller rocks, long dark strokes for crevices and shadows—the picture holds together because the darks all tie in with one another. Similarly, despite the activity within them, the distant rocks all come together in one large mass. The eye can also rest in the simply painted areas of the sky, the water, and the broad, flat rocks in the middle distance. Notice how all the crevices are placed so that they zig-zag you into the picture and toward the distant rocks.*

ROCKS

Learn to paint rocks by going out and painting them. Set up, look, and try to get what you see. Remember: rocks are usually hard and angular. Don't make them rounded, like potatoes. Watch how the shadows play across them, accenting their structure. Always look for the masses. It's easy to become confused by chips and crevices—so put your big light and dark areas down first. Later on you can cut them up, adding tops and sides, rifts and cracks.

Character is everything when you paint rocks. In *Rock Composition* (opposite page), for example, the rocks near the ocean are darkened and rounded by it. The large, flat rocks near the land are less stained. To the right, small pebbles have been rounded by thousands of years of abrasion. In the foreground big chunks of rock have stayed put for ages. The sea has had little effect on them—so they're still angular and sharp. The student looks at this site and sees just "rocks." After a little study, however, he begins to understand his subject; then he tries to develop ways to best represent the nature of the different materials.

BULGING ROCKS

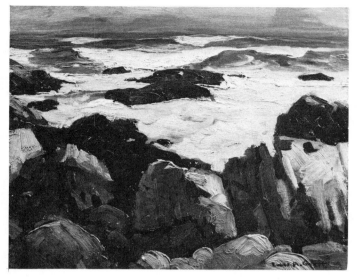

Low Tide, oil on canvas, 20" x 24" (51 x 61 cm.). I was attracted to this site by the contrast of the light water and the dark rocks. The sky is broadly painted and so doesn't detract from the main area of interest.

Detail. This is a group of boulder like rocks; they're near the ocean and have been battered and rounded by the water's action. The foreground pebbles are painted in heavy, rounded strokes — you feel the weight of the paint and sense that the area must be close to you. The large rock is painted with bigger, more angular strokes—each stroke describes a facet of the rock. Rather than carefully drawing crevices and then painting between them, I mass the rock in first. The crevices are added last—a few quick, thin, abrupt strokes. Don't put in too many or you'll confuse the viewer! The highlights are painted heavily and then cut to shape by the darker surrounding strokes. I've accentuated the brightness and texture of these highlights by placing them against a simple, flatly painted mass of background rocks.

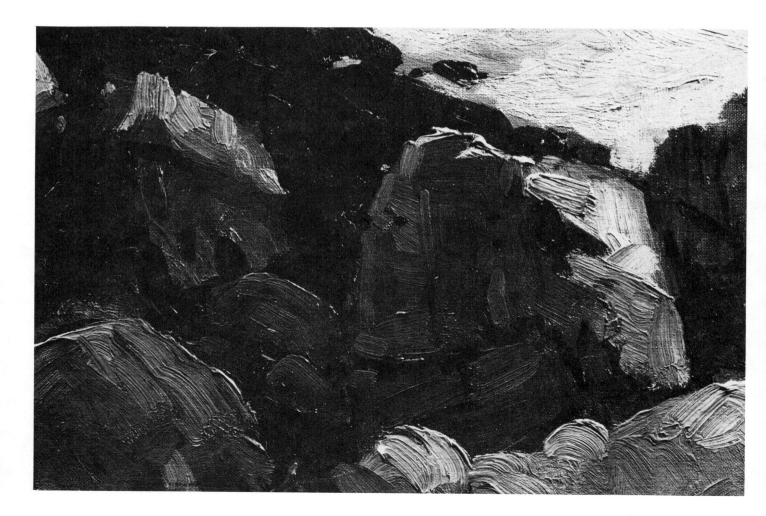

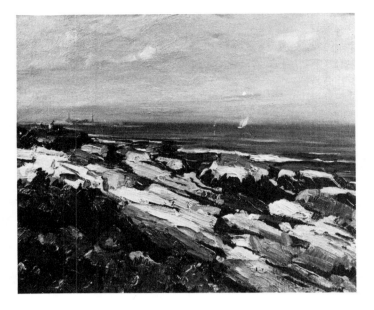

Twin Lights, oil on canvas, 20″ x 24″ (51 x 61 cm.). At this site I liked the angular, abstract quality of the layered rocks. They gave me a chance to use interesting colors and a variety of contrasting strokes.

Detail. Here an upheaval of the earth split the rocks in long, horizontal cracks. I tried to capture this diagonal, stratified quality. The large light rocks were slashed in with thick strokes. Then the area was cut to shape by the darks. Notice that to keep from having too much monotony of stroke — all diagonals moving to the right — the shadow in the center of the detail breaks across the mass in a vertical direction. It not only creates a sharp edge typical of the stone, but it also counterpoints the rock's movement. Cover the shadow area with your finger and see how the rocks lose much of their character. Notice that the strands of the brush, visible in the loaded strokes, suggest additional rifts and hairline cracks. The texture of the stroke is related to that of the material.

SMALL ROCKS

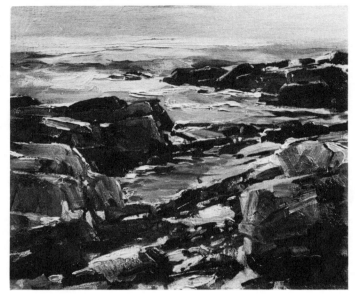

Against the Light, oil on canvas, 20" x 24" (51 x 61 cm.). When the light is behind your subject, you get a strong, dramatic contrast of light and dark shapes.

Detail. Among seaside rocks there are countless slivers and shards broken off by the surf or the ice that expands in the crevices during the winter. These slivers are sharp and brittle, and you can convey that character by an equally sharp and brittle brushstroke; here, each stone is made with one quick stroke. Remember, however, that you have to paint individual rocks without letting the picture break into a mosaic of disjointed strokes. I avoided that problem by first hooking the whole picture together with dark, simply painted areas of shadow. Looking at the picture the viewer first senses these big shapes. Then he sees the sparkle of broken rock catching the light. The small strokes are confined to the foreground; there are loads of equally small stones in the distance—but they're so far away that you can't see them. I've emphasized the smallness of the slivers by placing them near the massive, broadly painted rock on the right.

Hillside, oil on canvas, 30" x 36" (76 x 91 cm.). In Vermont the structural relationship between the rocks and the hills is always interesting. It's also easy to see because grazing cows eat the grass that might otherwise obscure the shape of the land.

Detail. The flat rocks are simply painted, a few light diagonal strokes giving them direction. Dark strokes accent the movement of the rocks; they either flow with the rocks (lower half of the detail) or form a diagonal counterpoint to them (upper half of the detail). The dark areas of the rock were placed before I painted the rocks themselves. The light, heavily loaded surfaces of the rock were then added and the darks redrawn. In and around the rocks the vegetation is represented by short, crisp strokes. In the center of the detail there's an area the cows couldn't get to—you can see the upright, zig-zag stroke of the long grass. At lower left one diagonal stroke is worked over another, the strands suggesting areas of flat, trampled grass.

25

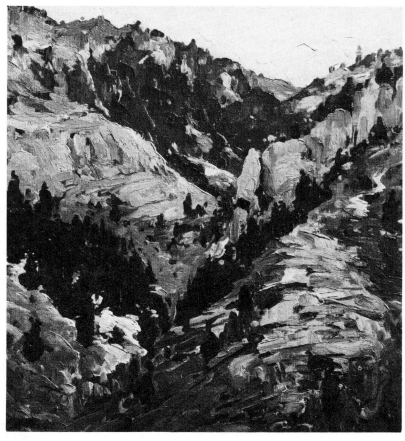

Pulpit Rock, oil on canvas, 18″ x 20″ (46 x 51 cm.). Here I was interested in the contrast between the vertical movement of the trees and the horizontal movement of the broken rock.

Detail. This whole area was split apart ages ago, leaving the rock twisted and broken into countless horizontal cracks. It's the same effect we studied in *Twin Lights,* page 23, but on a much more grand scale. I applied the paint thickly, the bristles of the brush again suggesting numerous cracks. I varied the color of the strokes so that some clearly stand out — that emphasizes the horizontal application of the paint. Thin dark strokes further accentuate this movement. Notice that only a few such dark strokes are necessary, and that these appear mainly toward the bottom of the mountain. These rocks are near to you, and you can clearly see such irregularities. The paint is also thickest in the foreground and gets thinner toward the top of the mountain and into the distance. With all the activity in the rocks I kept the vertical mass of trees simply painted. It's a big dark area, designed to set off the light rocks and counterpoint their horizontal movement.

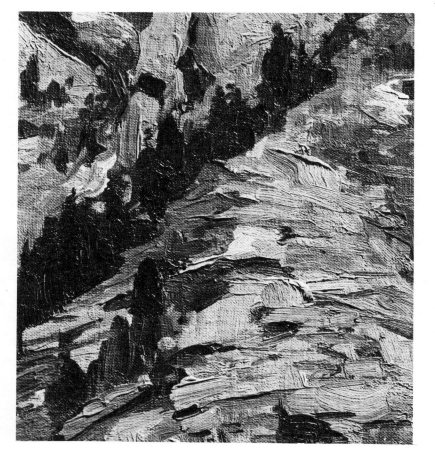

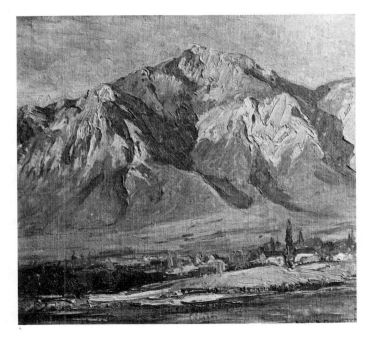

Ben Loman, oil on canvas, 18″ x 20″ (46 x 51 cm.). This mountain is the biggest in its area. I painted it just because it was so *huge!* Notice that the bottom is in a haze (the atmosphere is condensed in the valley)—while the mountain itself becomes clearer as it rises into the sky.

Detail. The grayish area in the lower half of the detail represents the timber line; the trees form a smoothly textured, velvety mass. Above them the rock is much more thickly textured. Snow constantly forms on the mountain, melts, runs off, and forms again. The rock has been cut and recut by the running water; as a result, it has a strong vertical texture. You can see how the strokes all move downward, with the paint strands suggesting the erosion caused by countless rivulets. I haven't added dark crevices—you couldn't see them from so far away. Instead, I let the ridges of paint suggest breaks in the rock. Some of the strokes go to the right, some to the left; they suggest the different facets of the rock. Subconsciously the viewer senses that if he can see so much texture in a distant mass, the mass must really be gigantic.

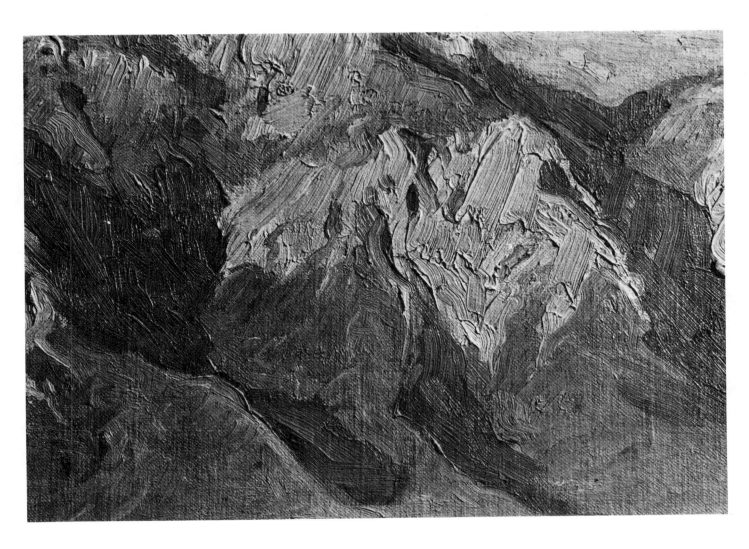

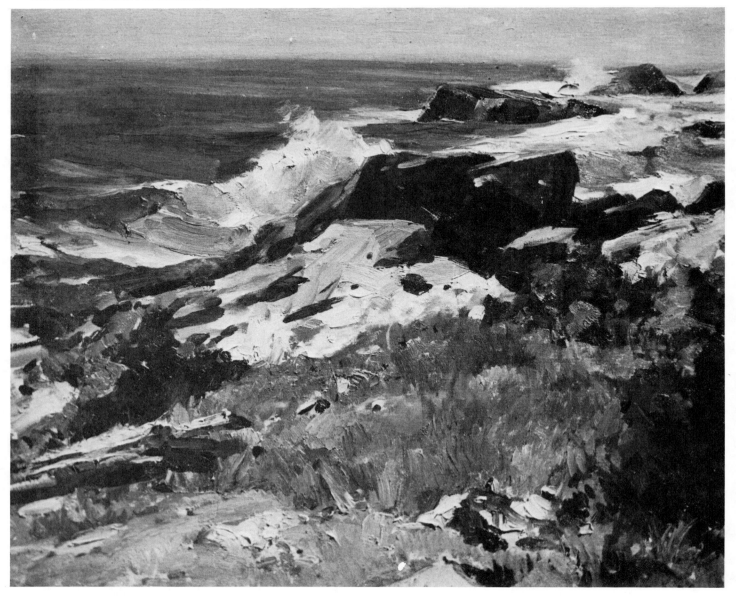

Grass, Rocks, and Roses, oil on canvas, 25″ x 30″ (64 x 76 cm.). I liked the contrast in material at this site. It had a little bit of everything—yet the rocks dominated the scene and kept it from becoming a confused mass of conflicting textures. The grass and bushes in the foreground are painted with short, squiggly strokes. The mass has a soft, blurred look that contrasts with the sharp, angular texture of the background rocks. These boulders are painted with thick, broad strokes. The water is very simply handled—it doesn't attract attention. Notice how the main dark rock is set off by the area of white water behind it. This dark rock is then used to accent the angular lines of the light rock in front of it. A few dark lines and dots add interest to the light rock mass, while a few light lines and dots add interest to the dark mass. Similar highlights and accents break up the foreground growth. Realistically, they suggest stones—but their main function is to keep the mass from being too flat and uninteresting.

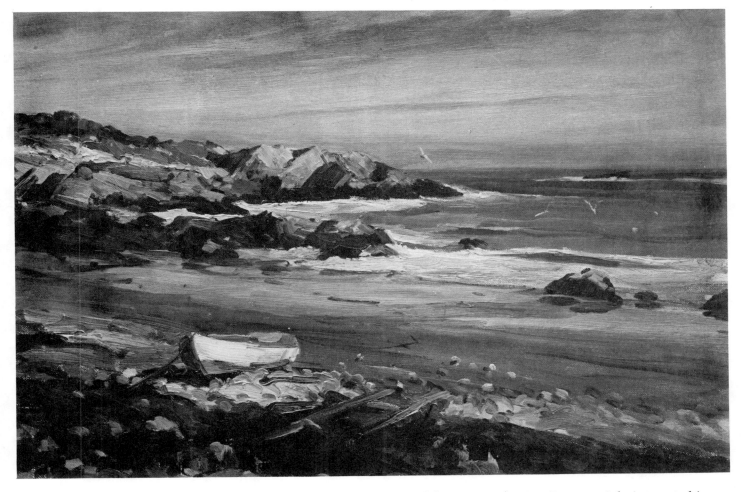

Twilight, oil on canvas, 24" x 36" (61 x 91 cm.). Here I was mainly interested in the wet beach and its reflections. I've placed a strongly lit, heavily painted boat in the foreground to give the area punch; it jumps forward, making the distant rocks stay in the background. Cover the boat with your finger and see how the picture loses much of its depth. In the foreground light dots and dashes suggest individual pebbles, rounded and tossed up by the sea. The rocks in the middle distance are kept low and fairly small so that they won't detract from the massiveness of the distant bluff. These low-lying rocks are painted with horizontal strokes; they're under water most of the time, and the ocean has smoothed some of their edges. Water never touches the tops of the background rocks, so they're painted crisply. They make a sharp silhouette against the sky. Notice that I've emphasized the way the beach fans out to the lower right by having the strokes in the sky all fan out to the upper right. Again, one movement counterpoints another.

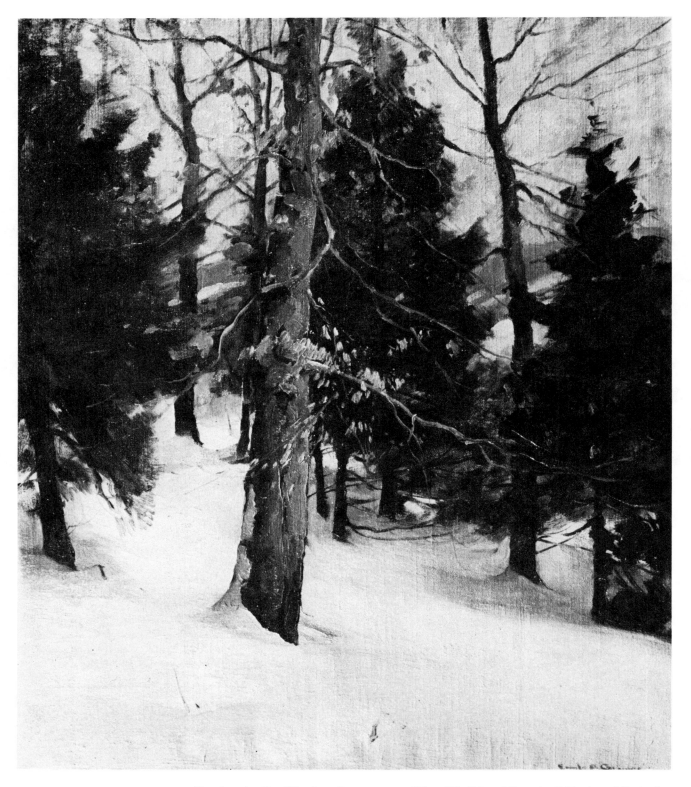

Beeches in the Woods, *oil on canvas, 30" x 25" (76 x 64" cm.). Collection of Betty Lou Schlemm. This picture was painted on a gray day in the middle of the woods. All the trees go out of the picture—you're hemmed in and would have to crane your neck to see the topmost branches. The curved stroke at the base of the beech tells you how the snow blew around the tree during a recent snowstorm (snow still sticks to the sides of the tree). Near the center of the beech, strokes representing a cluster of leaves break the vertical line of the trunk and give it added interest. These strokes are light against the dark, flatly painted firs and dark against the light sky. The bark of the tree is smooth, though there are vertical cracks here and there. The firs form a simple silhouette and act as a foil to the beech tree and its delicate branches.*

TREES AND FLOWERS

If you want to understand trees, you have to paint them outdoors—on the spot. That's where you get the accidental quality of nature—the unexpected bits that you could never think up in the studio. Two branches start together, part, then swirl back toward each other before dividing and going their own separate ways. That intricate back-and-forth movement is the key to the character of the tree. Yet many students fail to understand the importance of such fascinating movements. They make the two branches stick straight out of the tree—like spokes on a wheel.

Some trees—such as the elm—branch far up on the trunk, straight and dignified. Others—such as the apple—branch close to the ground and are much more playful in character. Despite the spot where the branching occurs, a general movement characterizes most trees. The lower branches drop down and then move up; they want to get out from under the heavy upper foliage. The middle branches grow horizontally to the sides. The top branches don't have to worry about overhead foliage; they grow straight toward the sun.

There's plenty of variety within this simple framework. The lower branches of a beechnut tree, for example, drop straight down. The sycamore tree's branches are characterized by stops, breaks, and angles. Maples are knotted and gnarled—they're big and dramatic—while a birch tree has a graceful and lyrical movement.

When I was starting to paint, my father, also a painter, was one of my hardest critics. "Your trees look like telephone poles," he'd say. They went straight into the ground. They didn't have a feeling of rootedness—of a footing in the earth. One day I finally broadened the base of a tree—and even showed part of its root breaking through the surface of the soil. I exaggerated the effect, but it looked good. And that was just what my father wanted! Remember, however, to broaden your tree near the ground. Some students start the flare just beneath the branches—and the tree ends up looking like an upside-down funnel.

After you've done study after study and sketch after sketch, you'll begin to understand the particular rhythm that distinguishes one tree from another. Once you sense the character of a species, you can begin to improvise. You may go out one day and see an especially fine movement in the branch of a birch tree. A week later you're painting at another spot and suddenly notice how that branch could enhance your picture. So you use it.

Develop your ability to improvise. Be literal at the beginning—and become more selective as you gain in experience. I used to go painting with a friend of mine—a really fine artist—and he'd always come over to my canvas and say "That isn't that tree! If you aren't going to paint it, why don't you stay in the studio?" He was partly right—you need to look and study when you're on a site. But he was wrong, too. Every painter has his own story to tell.

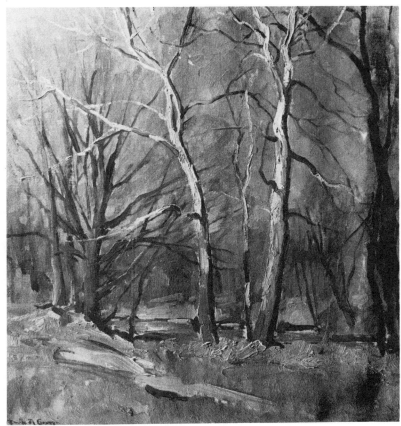

Sycamores Along a Creek, oil on canvas, 18'' x 20'' (46 x 51 cm.). I liked the way the two trees dance away from each other as they try to get to the sun. The main branches of both trees go to the sides, naturally avoiding the heavily foliaged area between the trees.

Detail. The sleekness and grace of the trees are accentuated by the smooth bark and the fluid movement of the branches. Each branch is only one stroke wide. To paint an area such as that shown in the detail here, I first establish the shadow sides of the trunk and branches and then place my highlights. I finish the process by redefining my shadows — that's when I cut the light areas down to size. The branch that moves across the center of the detail was first drawn with a dark stroke —short, light strokes were placed over it. Wherever the dark still shows, the viewer can imagine a shadow or some peeled bark. At the very bottom of the detail, I first drew the branch with a single *light* stroke; I then added some darks to accentuate where the branch bends and is thrown into shadow.

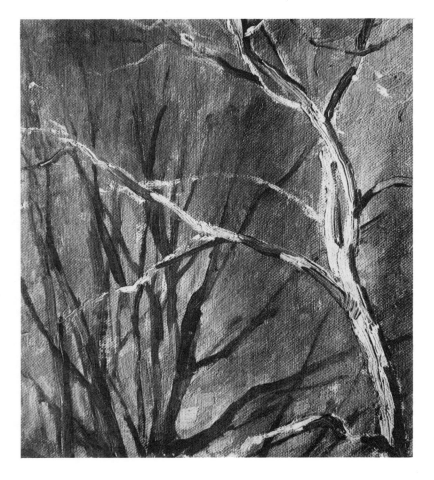

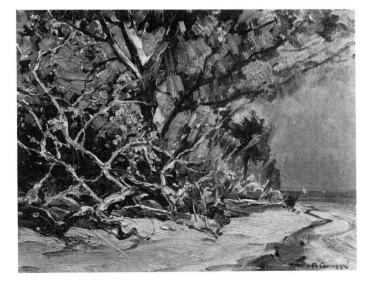

Seagrapes and Banyan Tree, oil on canvas, 16'' x 20'' (41 x 51 cm.). Seagrapes are a strange Florida growth with huge rounded leaves and extremely gnarled branches.

Detail. Again, the darks were placed first, leaving bare canvas for the broken pattern of the seagrape's branches. Then I loaded the highlights, almost modeling the roughly textured bark. I finished the area by going back over the darks, using them to refine and accent the highlights. Notice that the seagrape's branches are characterized by a rounded, convex movement — this movement recurs throughout the detail. The rounded leaves are just gobs of paint, applied once and left alone. The paint is applied so thickly that it looks as if I used a palette knife—but I didn't. A knife gives you a heavy impasto; but you can't get the sweep of branches with it. It makes everything look static. In the complete picture the eye finds relief from the activity of the seagrapes in the simple, flatly painted expanse of sky and beach.

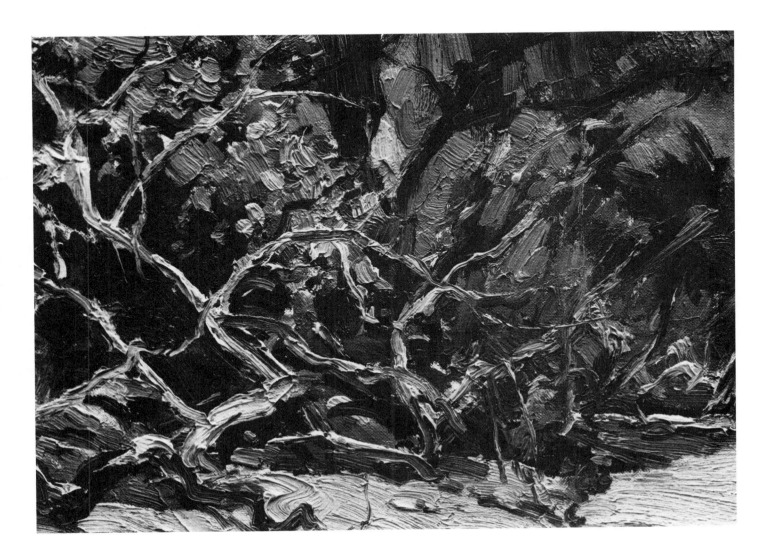

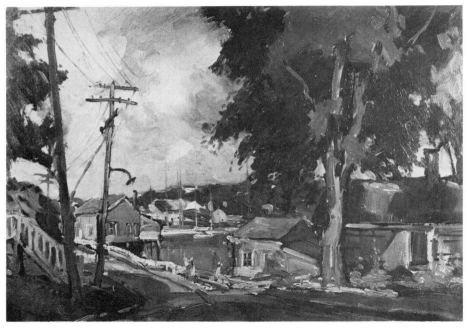

Rocky Neck, oil on canvas, 20″ x 24″ (51 x 61 cm.). This picture was painted in midsummer. The tree and the telephone poles frame the street that runs in front of my home and studio.

Detail. Most students look at a tree and try to paint every leaf. They forget that you see individual leaves only when you focus your attention on them. When the eye looks at a landscape, it see *masses* of foliage. The detail shows how the sunlit part of the tree is painted with a few broad strokes. The branches of the elm show here and there, giving a sense of how the leaves are attached to the main trunk. The leaves in shadow are another big mass—a simple dark accentuating the area of sunlight. Individual leaves appear only at the edges of the mass. A dozen small strokes are all you need; they explain everything else.

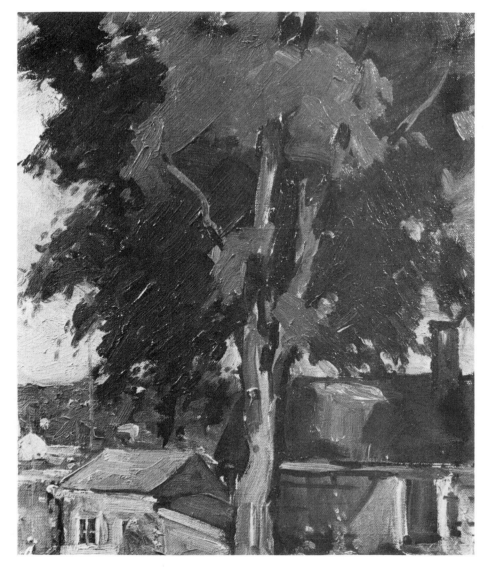

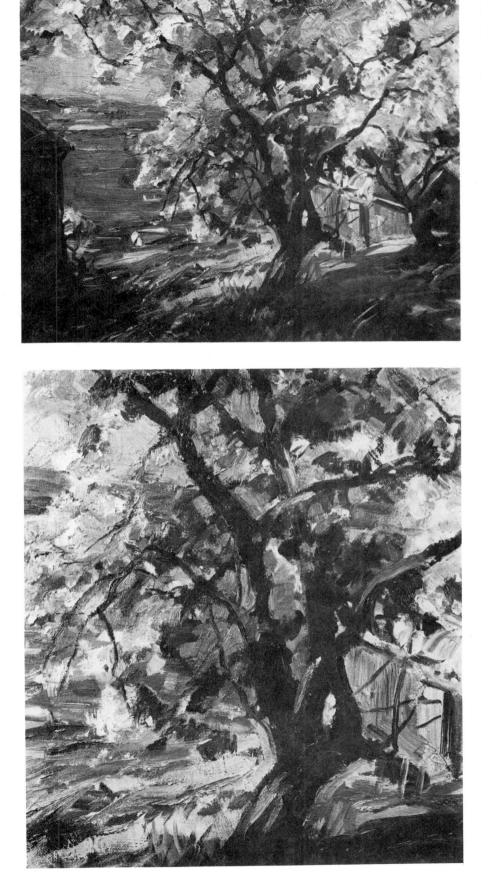

Spring, oil on canvas, 20'' x 24'' (51 x 61 cm.). An apple tree in bloom creates an interesting and decorative design. Here the mass is lit from the back; we see blossoms in light, blossoms in shade, and the masses of the coming dark, green leaves.

Detail. Although this mass is more broken than the one in *Rocky Neck*, the same principles apply. It's impossible to paint apple blossoms one by one — they're too small. So you paint them in a mass. This detail shows how the sunlit and shadowed blossoms are applied with big strokes, strokes that move in different directions — as would the blossoms themselves. The newly emerging leaves haven't thickened into clumps yet. In the upper right corner, for example, I've used small dark strokes to indicate this new growth. Since these few leaves don't hide the anatomy of the tree, you can see the interesting angular pattern of the apple tree's branches. These flatly painted branches hold together the active, explosive brushwork that dominates the upper half of the picture.

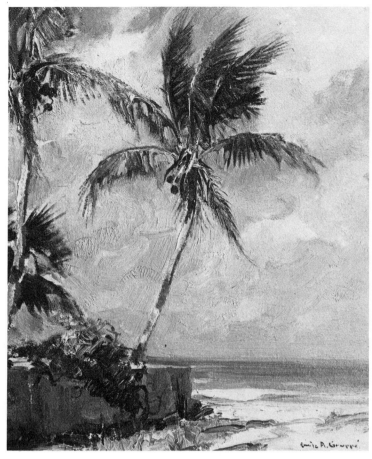

Palms in Naples, oil on canvas, 16″ x 20″ (41 x 51 cm.). Here I was able to emphasize the graceful movement of the palm tree by placing it against a simple expanse of sky.

Detail. When you paint a palm tree, try to capture the character of the individual fronds. The three fronds in the top center of this detail, for example, are the newest growth. They grow vertically out of the crown of the plant. They're painted with vigor—you can see how sharply the pointed leaves spring into the air. The leaves to the sides are getting older. They droop, and the leaves cross over one another; they haven't the same vitality as the newer foliage. Then, at the lower right, an especially old frond hangs down lifelessly. Compare the soft strokes used to paint that frond with the sharp ones used to paint the three directly above it. Notice also that the leaves of some fronds are painted right into the sky, while in other cases, the sky was stained with leaf color—and then this stain was cut to shape by strokes of sky color. There's always more than one way to skin a cat.

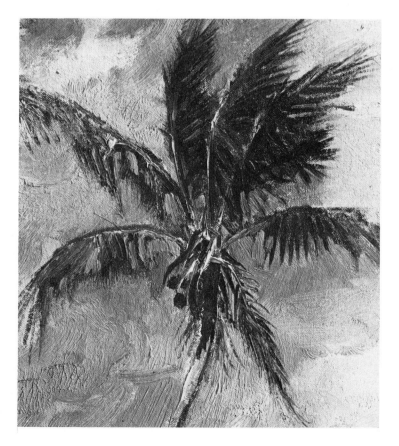

SOFT, RHYTHMIC FOLIAGE

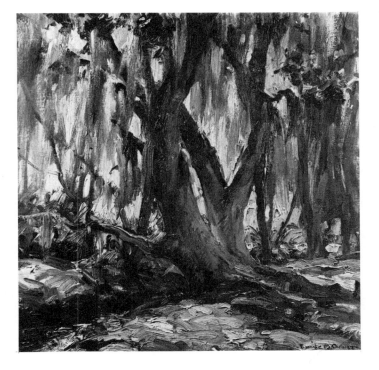

Live Oak, oil on canvas, 25″ x 30″ (64 x 76 cm.). Two things struck me about this Florida live oak: the eerie effect of the hanging moss and the way the back lighting created an interesting contrast between the dark tree silhouettes and the soft, semitransparent areas of moss.

Detail. I painted all the darks in the picture first. If you look toward the center of this detail, you can see how the dark preliminary block-in has stained the canvas; the tooth of the canvas shows through it. The area looks transparent—just as an area of thin, delicate moss should. Notice that its texture differs radically from the thickly painted branch directly beneath it. There the heavy impasto suggests the solidity of the wood and bark. Immediately above this branch the sky is painted with thick, loaded brushstrokes; you can even see the individual marks of the bristles. By loading my lights I make them stand out brilliantly. In the upper left of this detail you can see where I took a clean brush and, without adding any medium, gently pulled light and dark areas together. That creates a feathery interaction of values which suggests the lightness of transparent moss hanging in the wind.

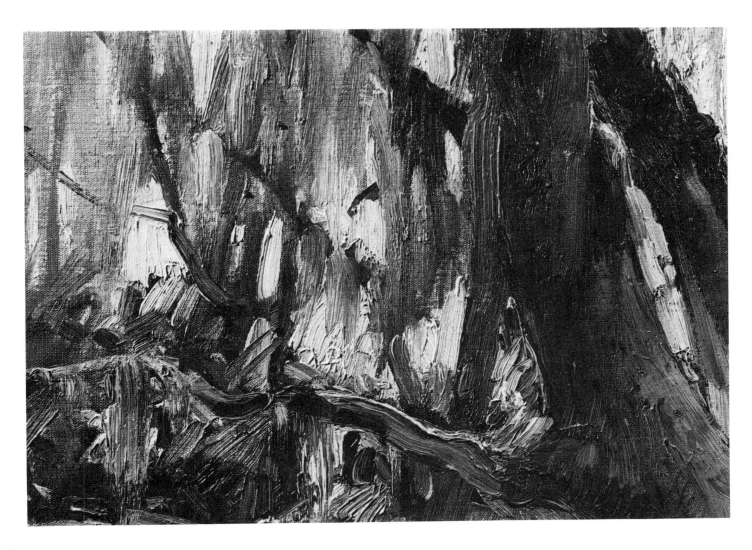

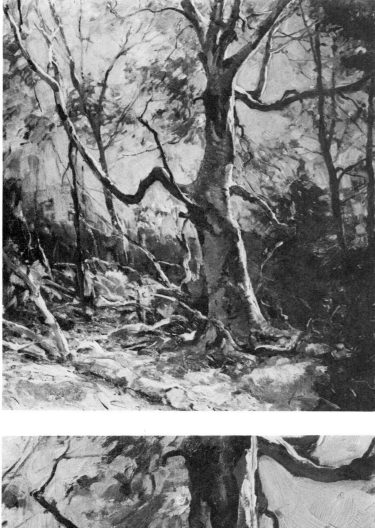

The Old Birch Tree, oil on canvas, 36'' x 30'' (91 x 76 cm.). This is a good example of the truthful effect that you can get only by working outdoors. I made a close study of the old tree's branches, paying special attention to the long branch on the left. In its search for the sun, it goes up, down, up, and finally out of the picture!

Detail. In the detail you can see how broken branches and the discoloration of the bark add interest to the tree. Birch bark grows in horizontal bands around the trunk, and here the brushstrokes follow the bark's direction. The bottom part of the tree slants to the left, and the diagonal strokes describe the plane of the trunk. The upper part of the tree moves in the opposite direction, as do the strokes. We saw the same principle at work when we studied how to paint the facets of rocks. The highlight along the right side of the trunk is heavily loaded. A small brush pulls highlight and shadow together in a squiggly line. The branches have less texture than the trunk. They're smooth and graceful shapes. Notice how these branches broaden as they approach the trunk—they're not just stuck into the sides.

Beach Study, oil on canvas, 16'' x 20'' (41 x 51 cm.). The interesting part of this study of a beech tree is the way the tree branches all move rhythmically to the right. One small branch moves to the left, but that simply balances the tree and acts as counterpoint to the main branches.

Detail. The background of the sketch is again painted thinly so it will stay back and not call attention away from the main area of interest: the foreground tree. This tree was blocked in with a thin stain, too; the heavier strokes were added only after I'd gotten my drawing right. Notice how the branches are formed by long, thick, fluid strokes of the brush; these curving, graceful strokes accent the rhythmic quality that attracted me to the tree in the first place. The trunk of the tree, on the other hand, is built up of short, choppy strokes. The bristles of the brush, visible in these thick strokes, suggest the broken texture of the bark. The vertical direction of the strokes accentuates the upward growth of the tree. Thin, dark lines added to the trunk complete the illusion. But don't overdo it! When one stroke looks good, there's always the temptation to add three or four more. And then you confuse the picture and lose your effect.

DECIDUOUS FOLIAGE IN FALL

Mount Mansfield, oil on canvas, 30″ x 36″ (76 x 91 cm.). I was mainly interested in the birch trees in this picture—but I also liked the majestic lines of the distant mountain.

Detail. I've again placed the main leaf masses first and then painted the individual leaves at the edges. There are three or four groups of leaves, but the groups are all interconnected. Small dark branches run through them, tapering rapidly off to nothing. They end in countless small branches—too many to paint individually. In order to get refraction around these branches, I lightly ran some dark paint over the nearby sky—you can see the quick swipes in the far left and right sections of this detail. Look at the complete picture above; you'll notice that there are leaves on only one tree. This could be explained naturally: one tree is younger and has better circulation than the other. But I actually removed leaves from the tree on the right so that (1) we could see Mount Mansfield clearly and (2) each tree would be saying something different. One tree shows you how the leaves look in the late fall. The other tells you something about the way branches grow.

Birches Along the River, oil on canvas, 30'' x 25'' (76 x 64 cm.). In this painting of birch trees along a river, the dark, simple fir acts as a foil to the lighter trees; it helps create a strong sunlight effect.

Detail. Here the brush is used to create three different textures. In the background tree mass to your right, the paint just stains the canvas. Here and there a thicker vertical stroke suggests an individual tree. The dark foreground fir tree is painted more thickly—with the stroke following the diagonal way the needles grow. Notice that at the bottom of the tree the branches go down to escape the foliage overhead, and then curve up toward the light. At the top of the tree the branches can go straight out and up — there's nothing to keep them from the sun. The horizontal strokes at the bottom of the detail (a riverbank) and the vertical strokes to the right (trees) create a standard of straight lines by which you judge the curve of the first branches. The tree itself remains a large, simple shape; it's rough enough to suggest a fir, yet smooth enough to stay back in the picture. The sunlit portions of the birch tree to your left are then painted heaviest of all. Notice the thin sapling on the far left. The bark is made up of a series of thick horizontal strokes. You sense the three-dimensional shape of the stroke; you *feel* that the tree must be close to you.

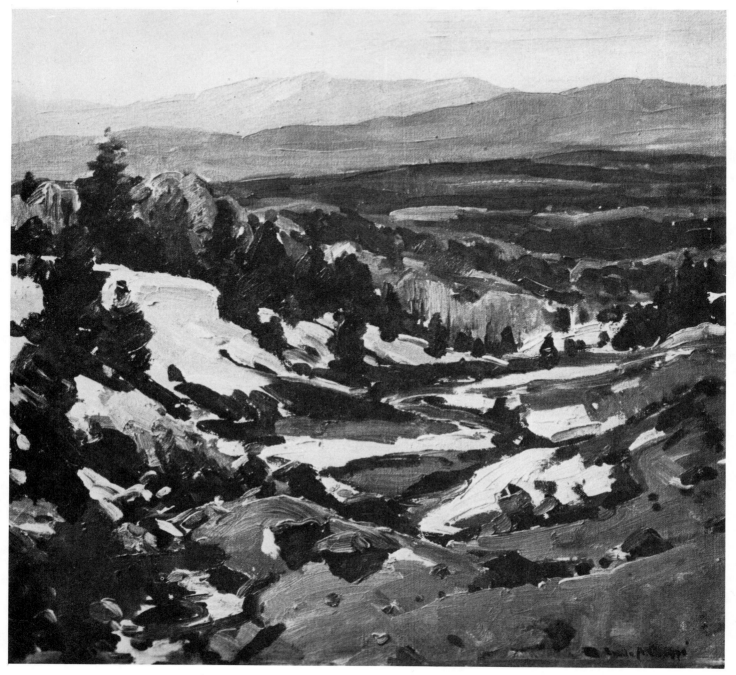

First Snow, oil on canvas, 18″ x 20″ (46 x 51 cm.). I was struck by the lively, staccato rhythm that a group of young fir trees makes against a large area of new-fallen snow. In order to keep the picture from breaking into a disorganized mass of dots, the dark firs are painted in groups, with only a few free-standing trees telling you just what all the others look like. A staccato rhythm completely dominates the foreground. Not only are the firs represented by a series of rapid dots and dashes, but so are the rocks, the crevices in the ravine, and the area of rounded trees in the middle distance. There is, however, a second rhythm working in the design—a flowing line that enlivens the rest of the picture by way of contrast. You can see it at work in the foreground, where dark accents swirl over the ground in rough oval shapes. These accents suggest the roundness of the earth; and they also help lead the eye into the distance. The simple, relatively flat area of background mountains acts as a foil to the active brushwork in the foreground. Notice how the heavy paint texture of the snow, dirt, and rocks makes these areas look close to you.

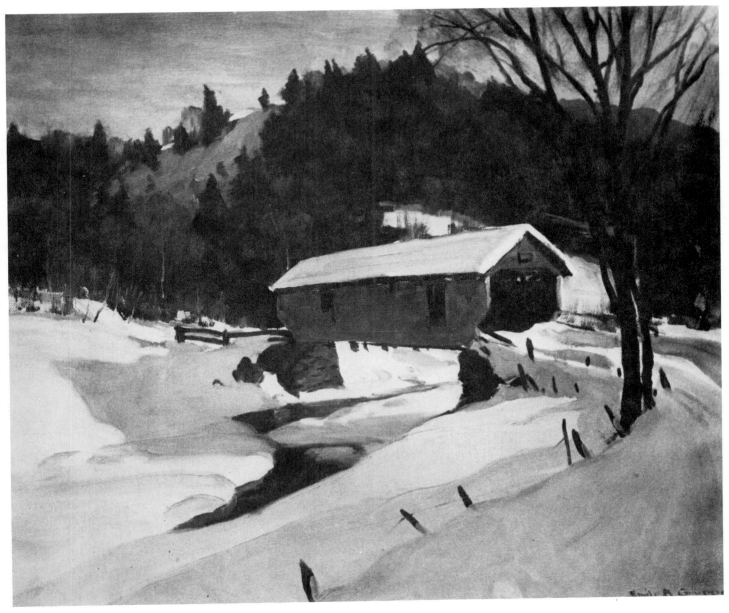

Covered Bridge, oil on canvas, 30″ x 36″ (76 x 91 cm.). The mass of fir trees acts as a simple contrast to the light forms of the foreground and the snow-covered bridge. The mountain mass is thinly painted; against a sunlit sky such masses become silhouettes, with very little modeling within them. Even the area of shadowed snow on the mountain (to your left) is dark and remains a part of the whole mass; students almost always make such areas much too light. The masses of firs and the nearer areas of deciduous trees are all handled with a similar vertical stroke—a stroke that suggests the way the trees grow. The large tree on the right reinforces this vertical movement. All these upright strokes are then contrasted to the long, smooth-flowing strokes of the foreground. Notice how convex these strokes are; they emphasize the bulging mass of the land under the snow. Notice also that the swirling foreground rhythms —such as that made by the water and melting, snow-covered ice—differ from the jagged, broken line of the evergreens against the sky. These varying rhythms work together, emphasizing one another by contrast.

FLOWERING VINE

Rocky Neck Studios, oil on canvas, 25″ x 30″ (64 x 76 cm.). The purple wisteria and the green urns in front of the studio formed an interesting contrast. The white house in shadow also gave me a strong foreground element.

Detail. Wisteria are a lot like apple blossoms; the individual blossoms are so small that you have to paint them as a mass. First I stained the dark shadow areas and then used heavier paint to describe the much lighter areas of wisteria in shadow. A heavy impasto represents the wisteria in full sunlight. The flower masses taper downward, with a few individual blossoms visible at the very end of the hanging plants. The wisteria to the right of center is the most thickly painted and has the most detail—though not much! I let this "finished" wisteria explain all the others. Notice that I've drawn part of the vine—one curving stroke—directly above the blossoms. That shows you how the plant got where it is. The vine reappears on the left edge of the roof, breaking the severe roof line and making it more interesting to look at.

FLOWER GARDEN

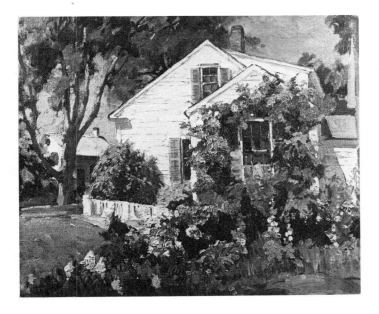

Hollyhocks, oil on canvas, 25″ x 30″ (64 x 76 cm.). I liked the way the flowers grew around the window of the house. The brilliantly colored mass was set off by the large clean expanse of the white house.

Detail. Both apple blossoms and wisteria had to be painted as large, textured masses. Hollyhocks, on the other hand, have large blooms with a clearly defined shape. This detail shows how the darks were stained first and the greenery worked over them. The heavily painted hollyhock to the right has its largest buds characteristically low on the stem, with the smaller buds toward the top. These buds are simple dots of paint. The leaves are similarly small toward the top. Near the ground they become larger and criss-cross over one another — each stroke represents an individual leaf. The other flowers are handled in the same way: a stain of color suggests background growth with the heavier textures representing closer leaves and buds. I wanted to get a sense of the spotty texture of the garden — without having to draw every flower.

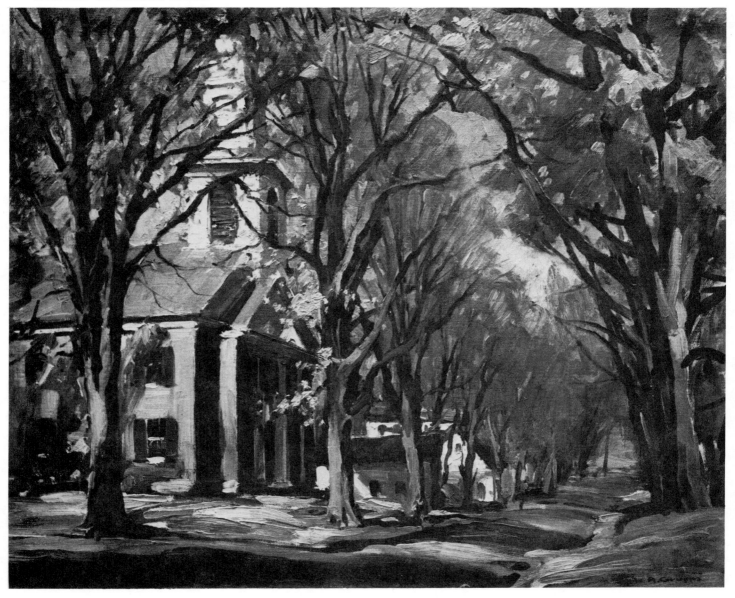

Deerfield Church, oil on canvas, 25″ x 30″ (64 x 76 cm.). This is basically a church picture. The church goes out of the top of the canvas, and the houses farther down the road, are all small in comparison to it. The tree on the far right is the nearest to us. We see the bottom part of its trunk and branches. The shadow areas were painted first and the bark brushed on with vertical strokes. Since there are many trees in the picture, it wasn't necessary to show the cracks in the bark, the knots, and all the other details you'd emphasize when studying an individual tree. The tree to the far left is farther from us and we can see more of its anatomy. The trees and branches are again painted flatly, becoming simpler and simpler as they recede down the road. In the distance they all come together in a large mass — an occasional dark stroke indicates a trunk or branch.

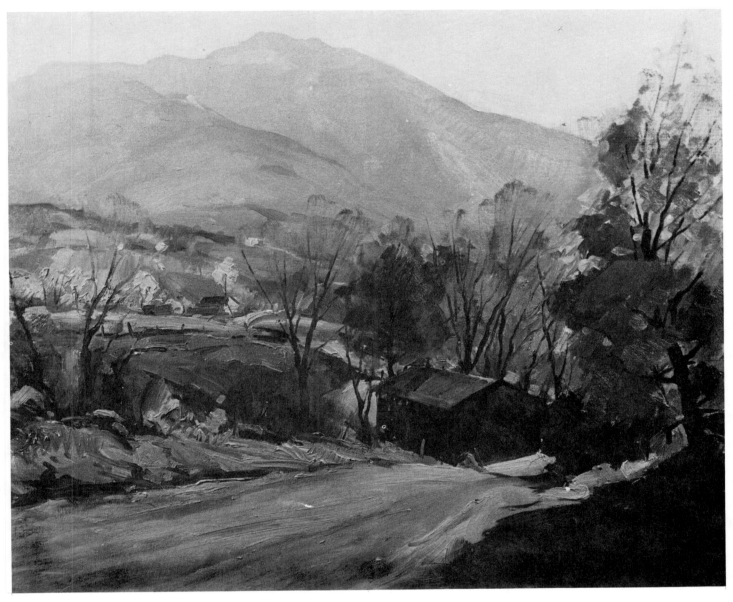

Pleasant Valley Road, oil on canvas, 30'' x 36'' (76 x 91 cm.). In the preceding picture the trees were a large and dominant element. In this picture they're merely props. The big tree to the right is large, detailed, and dark—you know it's in the foreground. As the trees recede, they become much simpler. To the left of center, for example, there are a few light fall trees near the distant farm. The foliage is indicated by a couple of thick paint strokes—a line suggests a trunk. Farther back, even the trunk disappears, and all you see are a few light dots. (You can see three of them at the foot of the mountain.) These dots are colored like the foreground tree on the right. That detailed tree explains the more impressionistic ones. Near the bridge the tops of the bare trees are suggested by a few vertical strokes of the brush. All the trees in the picture are kept small to emphasize the height of the distant Mount Mansfield.

Rocks and Trees (above), oil on canvas, 30'' x 36'' (76 x 91 cm.). The sun is directly in back of this tree, silhouetting it and giving an interesting and colorful character to its fall leaves. The leaves have a strong texture to them, but, as in previous examples, they're painted in big clusters with individual strokes visible only at the edges. In some areas the leaves are painted into the wet sky (lower right). In others the sky is painted into the mass of wet leaves (upper right). The leaf masses swing downward to the right on the right side of the tree and to the left on the opposite side. They naturally grow this way —and it's more interesting than having the leaves all going in one direction. A clump of leaves cuts across the center of the tree and unites the foliage on either side of it. Probably the most important element in the whole picture is the smaller tree on the left. It fills the left side of the canvas and forces your eye to move toward the main story: the long horizontal branch on the right and the leaves that obscure it.

The Old Beechnut Tree (right), oil on canvas, 16'' x 20'' (41 x 51 cm.). I was struck by the sheer age of this tree: the knots, the peeled areas near the ground, and the discoloration of the bark. The bark grows around the tree in horizontal bands — the strokes follow that direction, with the visible strands of the brush representing breaks in the bark's surface. Notice, for example, how the strokes work around the knot, almost modeling its protruding shape. On the right side of the trunk there's a bulge in the bark; short, sharp strokes follow the plane of the bulge, clearly showing how it relates to the main trunk. The dark uncovered wood at the base of the trunk is also given a separate character by its color and the way it's painted. Vertical strokes contrast with the horizontal movement of the bark-covered areas.

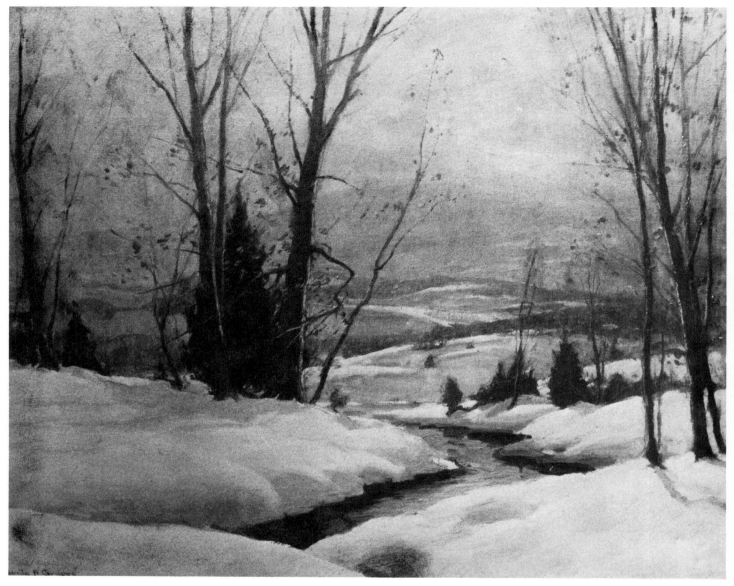

Snowbound Creek, oil on canvas, 30'' x 36'' (76 x 91 cm.). This was painted on a misty day; the sun broke through the clouds and lit the distant hills. Since the sun is directly in front of us, the trees become dark, flatly painted silhouettes. I've added interest to these simple silhouettes by surrounding them with a lively pattern of leaves. The design doesn't look spotty, however — the small strokes are kept close to the main trees. These trees form a ''screen''—you look through them to the subtly illuminated distance. In order to emphasize the **trees** the snow is painted in large, simple masses. It's soft and smooth. The **trees** are pulled decisively out of the picture. That scales the design; you sense that the foreground creek must be very small.

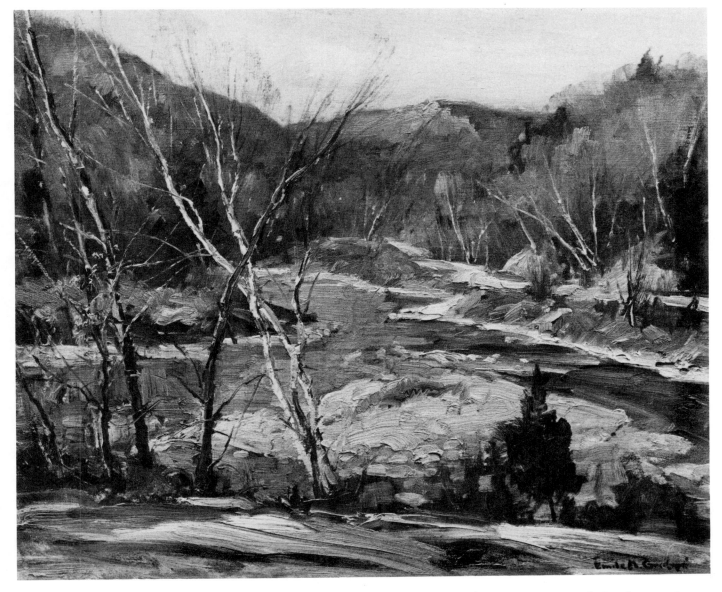

Pebbles and Water, oil on canvas, 25'' x 30'' (64 x 76 cm.). In the previous picture I pulled the trees out of the composition. They were the main interest, while the distance was a subsidiary element. Here I keep the trees in the picture; the trees are a subsidiary interest, and the river is the main subject. (I had a good time painting the sand bar in the middle of the stream. Large strokes near the foreground suggest individual river stones—similar but smaller strokes represent rocks in the distance. The day is bright and creates a lot of strong textures. Compare the flatness of the trees in *Snowbound Creek* to the more rounded, textured trees here. Notice that the background trees merge into a large mass. The distant birches stand out sharply against this mass. They're painted with thin strokes that fan out in a star shape. Trees on a slope usually grow at angles to the slope. And when you get a cluster of trees, each goes its own way, avoiding the branches and leaves of the others.

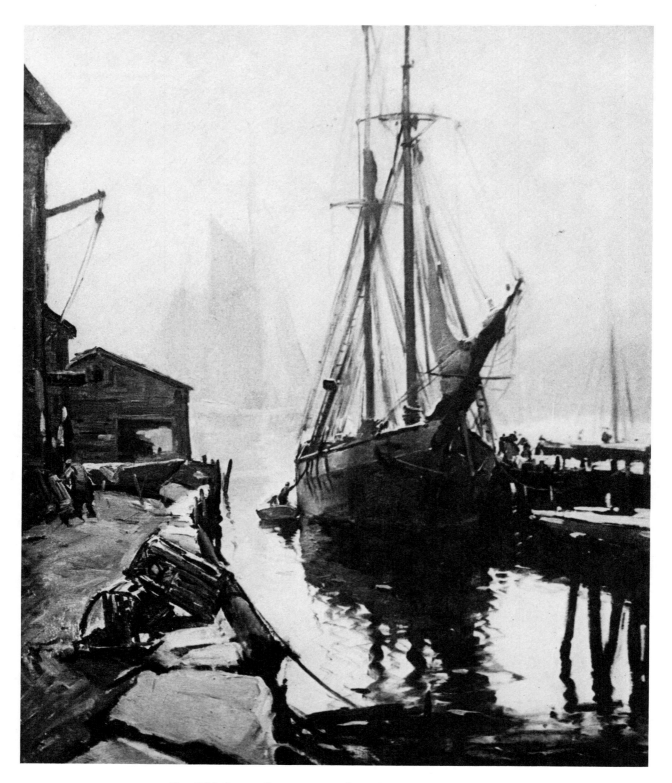

The Old-timer, *oil on canvas, 30" x 36" (76 x 91 cm.). Here the sky is heavy with fog and relatively textureless. Remember that fog is thick and obscures everything it touches. You can barely see the schooner in the background. The building at the end of the wharf is hazier than the building close to us on the far left. The bowsprit of the schooner is near to us and dark; the mast behind it is a little lighter; and the one behind that is lighter still. You can clearly see the strokes that make up the foreground lobsterpots—these prominent strokes help bring the area forward (cover them with your finger and see how the picture loses some of its depth). Similarly, the bold, dark strokes of the mud establish a foreground and throw the boats and wharves into the distance. These dark strokes also unify the picture. They tie together the stone pier, the reflections, and the wharves at the right.*

SKIES

When you're outdoors, first determine your light source. Is the sun on your left or your right? In front of you or behind you? Then maintain that light consistently throughout your painting. The sun moves in the sky, and you have to remember how things looked when you first started to work.

Try to feel the mood of your subject and paint the sky accordingly. If you're working on a foggy day or at a quiet moment in the early morning or late afternoon, a bold, heavily textured sky might detract from the peacefulness you want in your picture. A flat, simple sky would better match the character of the site. A bright, windy day, on the other hand, might impress you with its active, twisting clouds. You feel alive and paint energetically, using rhythmic strokes applied with your whole arm.

Flat skies present few problems to the student, but cloudy days are a different matter. When you paint clouds, you should learn to look for their general movement — then use the ones you think best fit your painting. Remember: overhead you see mainly the rounded undersides of the clouds. In the distance the bases flatten out, and you see instead the billowing shapes of the clouds themselves. Overhead the cloud bases have ragged, diffused edges — they're close to you and you can see how the wind blows them around. In the distance you can't see such subtle transitions, so the background clouds actually appear sharper and clearer than the ones nearer you. We notice this same effect when we paint ice melting in a river. Nearby the edges look soft, but farther upstream they all look sharper. Also remember that on a cloudy day you don't see much light overhead. You just see the large cloud bases. The lights are all in the distance, where the sun hits the fully exposed sides of the clouds.

The student's greatest problem occurs when he tries to get perspective in his clouds. Pretend you're painting a road in the sky. The same principles apply — but you look up at one subject and down on the other. The biggest shapes are all in the foreground (overhead); and as you go back, the shapes get rapidly smaller. Students draw what they *think* is a big cloud. But "big" in relation to what? They forget that they're designing on a particular size surface and everything has to be shaped in relation to that surface. So their big cloud might cover only an eighth of the foreground sky. Clouds like that look like puffballs. They don't recede into the picture. Make a cloud base overhead fill half the foreground! Then have the background clouds very much smaller. The strong contrast in sizes will pull the viewer into your work. Look up as you paint—try to get a feeling of the full expanse of the sky, not just the part you see under the brim of your hat. It's like standing in the middle of a road to get a sense of its size. When you feel that a thing is big, do everything you can to get that feeling down on canvas!

CLOUD LAYERS

Clouds over Woodstock, oil on canvas, 25'' x 30'' (64 x 76 cm.). The billowing clouds cast shadows. I was interested in the texture of these clouds and the light–and–dark pattern they create on the rolling hills.

Detail. You can clearly see that the clouds get smaller and smaller as they recede into the picture. The strokes follow the movement of the mass. The sunlit parts of the cloud, for example, are built up of rounded strokes. They're cut to shape by the shadowed parts of the clouds, parts painted with both rounded and diagonal strokes. In the distance the cloud bases are mostly horizontal strokes. As the clouds come overhead, we see more of these bases. The strokes then have an added liveliness to them. The trouble with this picture—and the reason I included it in this chapter—is that it's much too static. The cumulus clouds are painted in separate horizontal groups; since none of the groups are connected, they look like a bunch of puffballs. I painted the clouds as they were–but I didn't get a sense of design or of life into them.

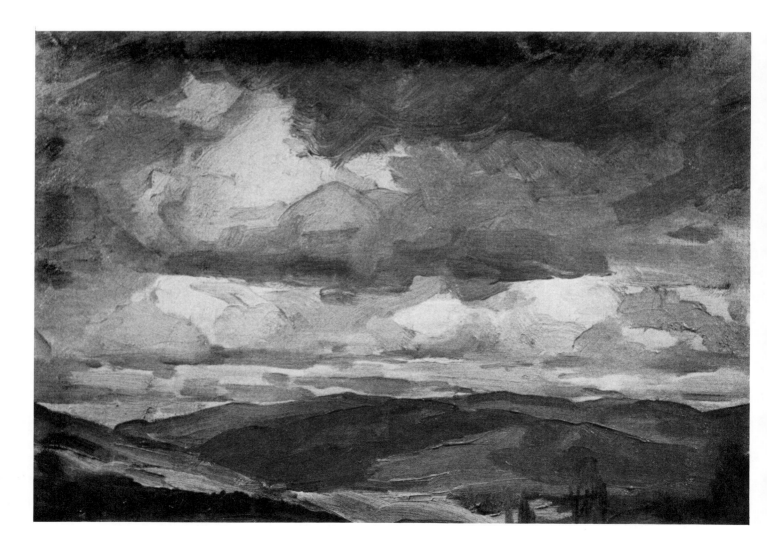

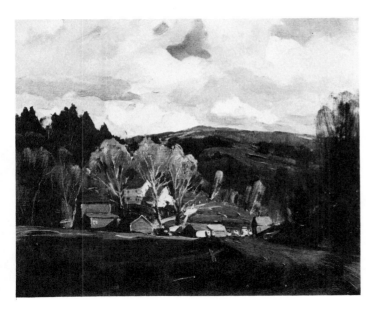

Farm on the Hill, oil on canvas, 20'' x 24'' (51 x 61 cm.). I painted this picture a number of years after the preceding one. Again I was interested in the cloudy sky and the dark shadows cast on the landscape.

Detail. Unlike the previous detail this one shows a much greater movement in the sky. I've interconnected the dark strokes of the cloud bases; the diagonal lines make the whole area more dynamic. As I painted these bases, I tried to feel their upward movement. The most strongly lit clouds are near the horizon—where I've emphasized them by bringing them against the dark mass of mountains and trees. Keeping your sunlit clouds low in the picture not only brings them nearer your center of interest (a bright cloud against the upper edge of a frame can be very distracting) but it's also more natural. In the distance you see more of the sunlit sides of the clouds. Overhead the strokes become broader and more noticeable. You can see the texture of the clouds because they're nearer to you.

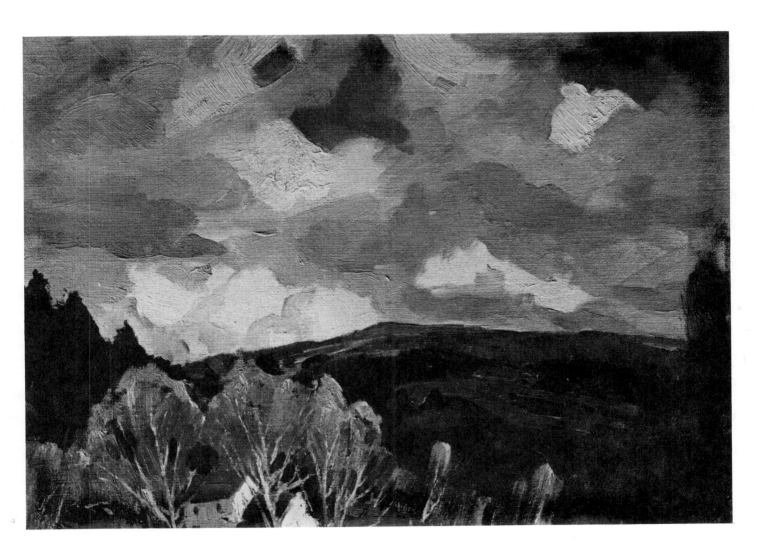

SUNLIT CLOUDS

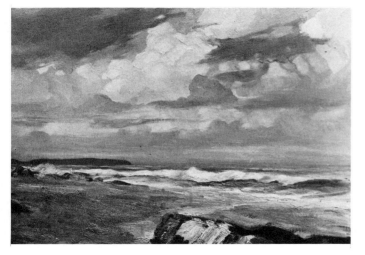

Cloudy Day, oil on canvas, 30″ x 36″ (76 x 91 cm.) The huge cumulus cloud in the center of the painting built slowly into the sky. It took its time and must have stayed on the horizon for almost an hour —I had plenty of time to study it.

Detail. As the cloud climbs into the sky, it gets nearer the sun and becomes lighter. The strokes again follow the bulging, rounded cumulus shapes. In order to emphasize the vertical movement of the cloud mass, I've run a number of stratus clouds (long, low-lying clouds) horizontally across it. The stratus clouds are dark, since they catch the light only on their upper sides. These low-lying clouds fan out from the left side of the picture, which gives them perspective. They straighten out and become smaller as they go into the distance. The largest clouds are directly overhead and are painted with the most prominent strokes.

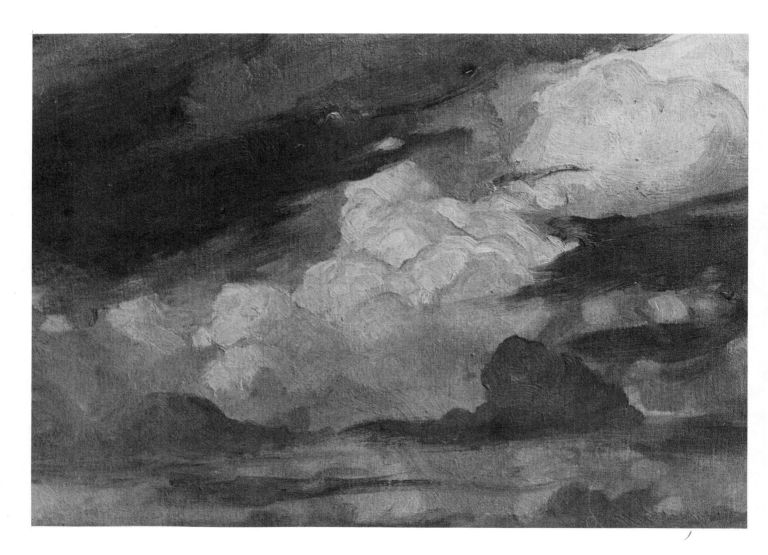

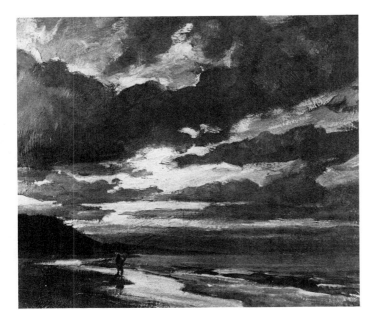

Fisherman at Twilight, oil on canvas, 20'' x 24'' (51 x 61 cm.). In this picture I was interested in the dramatic pattern created by the backlit clouds and the glare on the beach. The effect was a fleeting one, and I had to paint it very quickly.

Detail. In the previous painting the clouds were hit head-on with a blast of sunlight. They were therefore very bright. In this case the sun is behind the clouds; they become simple, dark silhouettes. I've emphasized this flatness by painting them with a minimum of texture. The darkest clouds are directly in front of the setting sun. As the clouds go into the distance, they catch more of the sun's light and become brighter. I laid down the heavily loaded areas of sunlight first and then cut them to shape with the dark clouds. Toward the edges of these dark clouds, the material thins out and more light shines through. I let the light color work into my dark stroke. The clouds are dark, but they're not as dark as the headland on the left. Against the light this spit of land is almost black. Notice that the clouds fan upward to the right, while the beach fans downward in a contrasting line. This counterpoint adds dynamism to the design.

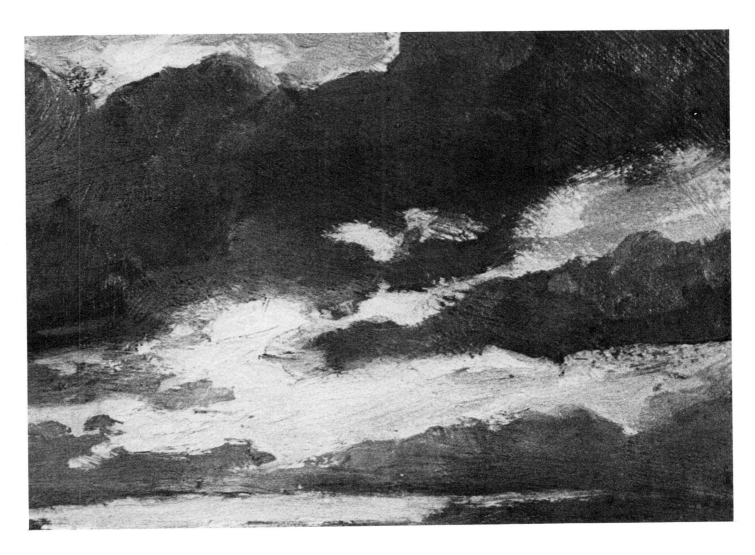

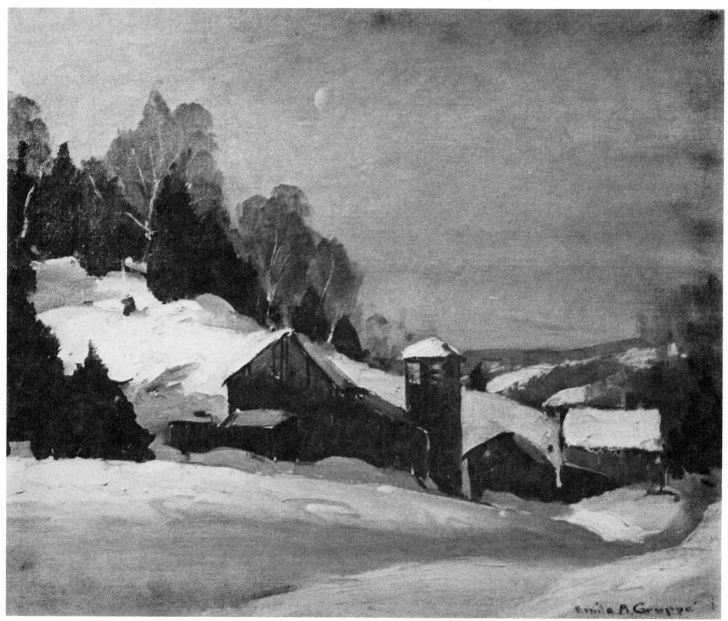

New Moon, oil on canvas, 20'' x 24'' (51 x 61 cm.). I headed out early one morning to paint some birches—but saw this scene as I turned a corner. I had to paint it. The sky has almost no texture. An active sky would have conflicted with the quiet mood of the piece. I also kept the sky simple so you could see the subtly painted moon. The sky is darker than the sunlit areas of snow—that gives the snow a chance to register. The flat simplicity of the sky is repeated in the handling of the trees, the buildings, and the foreground masses of snow. Strong textures are at a minimum, and the scheme is dominated by a restful horizontal movement. Since I wanted to emphasize the sky, I scaled everything else to fit it. Notice how small the buildings are. I've gotten in the whole farm: barn, silo, sheds, and farmhouse.

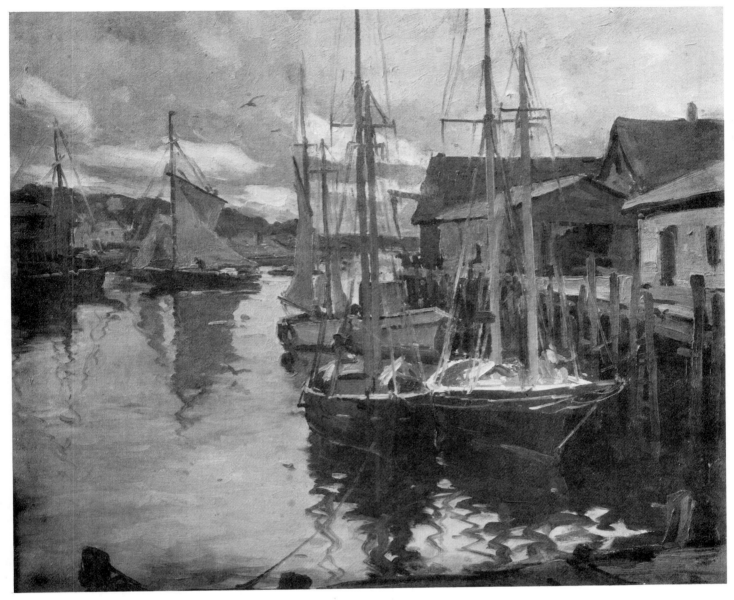

Gray Day, Gloucester, oil on canvas, 25" x 30" (64 x 76 cm.). On an overcast day you don't really see cloud shapes and textures. They all come together into a large, flatly painted mass. The buildings and water are all thrown into shadow. The values are close together, and the strong lights are in the sky. In order to emphasize the light in the sky, I've brought my contrasting dark masts up against them. Because the gray sky doesn't throw a strong light on the buildings, they tend to blend together. The strokes of the buildings in the foreground are similarly broad; there's no light to highlight individual boards and shingles. The still water is painted with quiet, horizontal strokes—a few dark spots suggest ripples. In order to keep this large area of water from being too monotonous, I've broken it with the large reflection of the dark background sail. This reflection, too, is flatly painted.

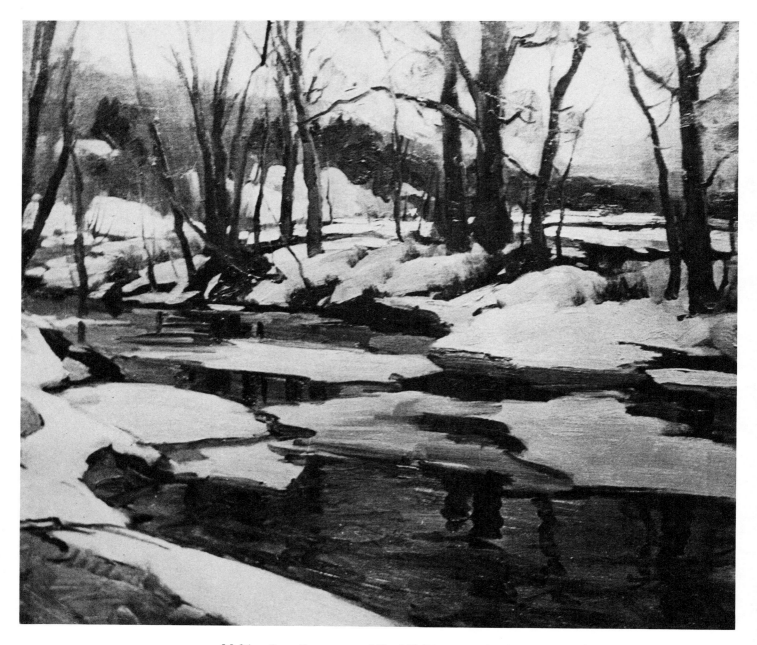

Melting Ice, *oil on canvas, 30" x 36" (76 x 91 cm.). The strong pattern of the water and the rapidly melting ice attracted me to this site. The snow on the land is painted with convex strokes following the shape of the land beneath. The flat, snow-covered ice is painted with broad horizontal strokes. In the center the strokes for water and ice are pulled together, creating a soft edge that suggests melting ice. The ice blocks the stream and keeps the water relatively still. The reflections are therefore straight and clear. In the foreground a few large, dark strokes suggest ripples. In the distance you can't see the ripples on the water — the paint texture is much smoother. Notice that the areas of snow and ice are interconnected, giving you an S-shaped path into the picture.*

WATER, ICE AND SNOW

There are no formulas for painting water, ice, and snow. The important thing is to *feel* what's happening at a particular spot. What is the *nature* of the water, ice, or snow that you're going to paint? You won't paint a rushing stream the same way you paint a quiet pond. One is full of activity—and you convey the energy by a similarly energetic use of the brush. The pond, on the other hand, might be more broadly handled, with large strokes and a minimum of activity in the water.

Is the water transparent? If it is, then its color and value will be affected by the mud, rocks, and dead leaves beneath it. If it acts like a mirror, it will reflect the color of the sky overhead (the reflected sky color will be darker, since the water absorbs some of the light). Are you painting old or new-fallen snow? New snow is reflective; it bounces light into shadows and looks brilliantly white itself. Old snow is more porous and "corrugated"—it doesn't reflect light as effectively and is therefore darker than new-fallen snow. Is the ice made of fresh or salt water? Harbor ice has salt in it and is very grainy; it's never as bright as the smooth ice you find in freshwater ponds. Is the snow melting or frozen? Melting snow has a "soft" feeling; stroke merges with stroke, with minimum contrasts. Cold snow is "hard" and brittle—you can use sharp edges and strong contrasts to emphasize this quality. Remember that knowing about white water can help you paint white snow—but each has its own special character.

Ask yourself: What is your physical position in relation to your material? I had a friend who painted fishing boats from a specially rigged dory. He played down the water and emphasized the way the boats loomed over his head. The effect was striking, but I always felt that his low position made the foregrounds of his paintings too monotonous. All you saw was a bit of straight, flat water. When you're above the surface of the water—on a wharf, for example—you can look *down* on the swirling ripple patterns. These patterns naturally move into the design—so I always try to make good compositional use of them. You can paint foreground water with a herringbone stroke, working diagonal slashes back and forth across one another. Or you can paint it with figure-eight strokes, circular strokes, S-shaped strokes—whatever gives the water a sense of movement.

Streams are popular with artists because they, too, naturally zig-zag the viewer into the composition. The strong perspective and the rhythmic movement are there. I remember painting one day with an old instructor of mine. He set up along a stream, but I couldn't make sense of the subject—I painted elsewhere. About an hour later I came back and found he'd seized on the rhythmic, angular movement of the creek, exaggerating it with tremendous effect. He saw the design potential in the subject—while I only saw the nonessential details.

STILL REFLECTIONS

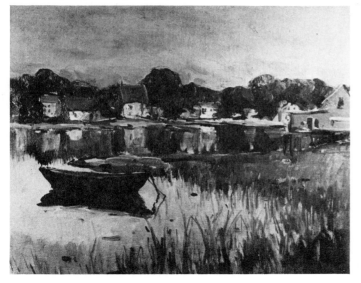

Dory at Anchor, oil on canvas, 16" x 20" (41 x 51 cm.). Here I was struck by the dark silhouette of the foreground dory. Because it's so dark, the eye immediately seeks relief in the sunlit background.

Detail. On still, quiet days the reflections are almost motionless. Here I've painted the reflections of the houses with vertical strokes, moving the brush rapidly up and down to create a jagged edge. Since the water absorbs some light, the bright buildings reflect a little darker, the dark trees reflect a little lighter, and the middle tones stay about as they are. The trees are simple, rounded shapes—their main function is to set off the buildings and the reflections. Notice in both this detail and in the complete picture that the vertical movement of the houses and their reflections is picked up by the strokes used to describe the nearby marsh grass. This vertical feeling is very important; without it, the horizontal movement of the bank and the boat would dominate the picture. One stroke relieves another.

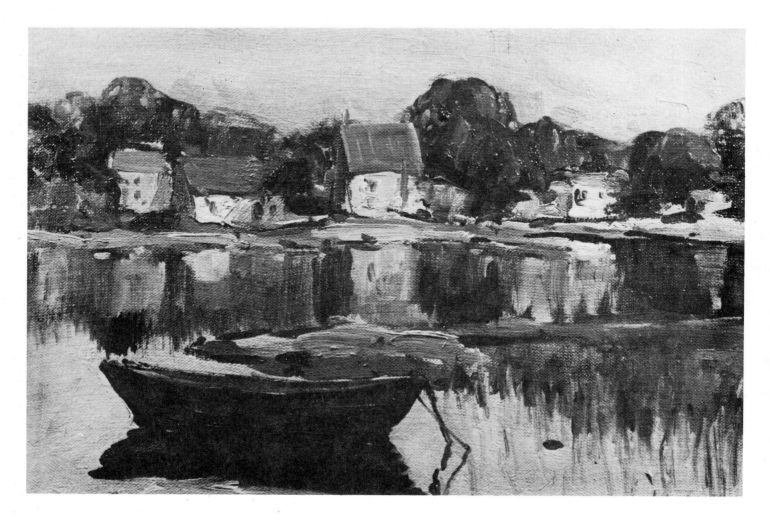

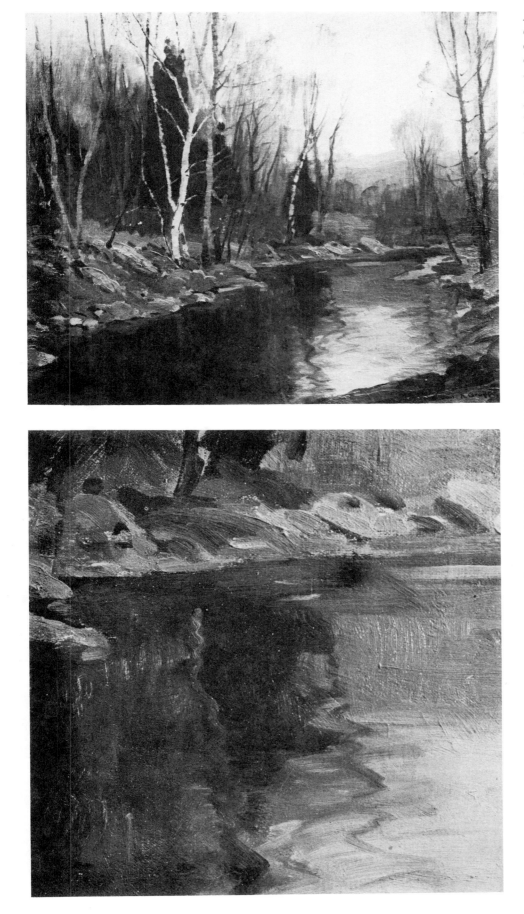

REFLECTIONS IN A POND

Aspens and Birch Trees, oil on canvas, 25" x 30" (64 x 76 cm.). This was a silvery, overcast day. The clouds acted like a lamp shade, diffusing the light of the sun. As a result there are no dark shadows in the picture and no brilliant highlights. Upstream the reflections are still and flatly painted; you can't see motion in the water as it gets far away from you. Distant mountains and trees reflect as a simple mass. In the reflections near us, however, the motion of the water is more clearly visible. And in the foreground the action is very pronounced.

Detail. In the center of the detail you can see the reflection of a birch tree. The stroke is light when it's against the dark reflection of the fir tree — and becomes dark as it emerges into the lighter water. Notice that I haven't drawn the reflection of each tree branch. The branches are suggested by a few brushstrokes; they're just a tone in the water, a blur. If I'd drawn every branch, the water would have been too broken up. The peacefulness of the scene depends on my keeping my masses big, flat, and only slightly textured.

63

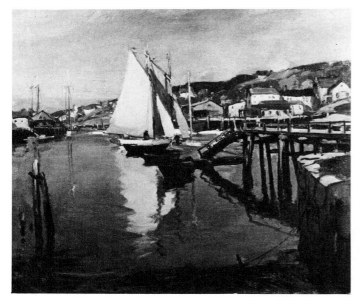

Sailboats at Dusk, oil on canvas, 25" x 30" (64 x 76 cm.). This picture was painted late in the day as the shadows began to creep up the sail. The sail and its reflection formed one large, interesting shape.

Detail. The reflections in this fairly quiet harbor start straight, but as they near us, they get more of a wiggle to them. You're looking down on them and can see the distortions caused by the ripples on the surface of the water. The dark boats and their reflections are painted as a simple, relatively textureless mass. The dories, the pier, and the shadowed side of the float form a single dark shape. These strong darks cut into the lighter reflection, emphasizing it by way of contrast. Remember to keep such light and dark contrasts near the focal point of your work. Sharp contrasts at the edges of a painting only distract the viewer from your main story.

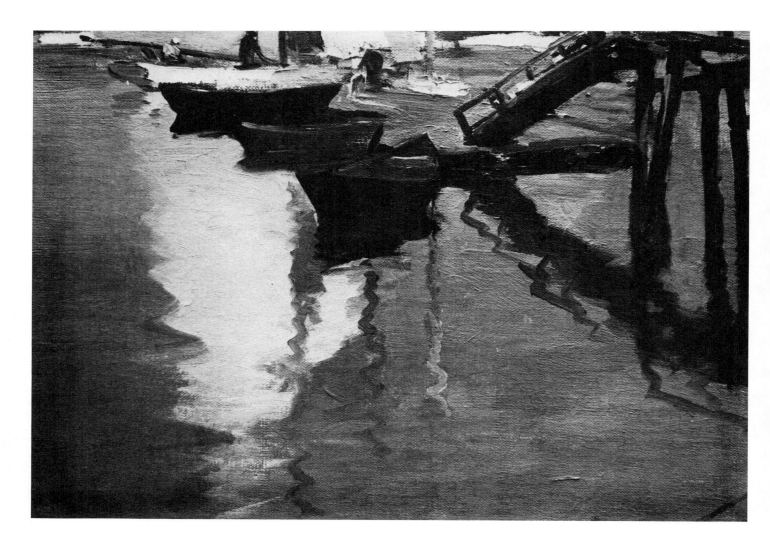

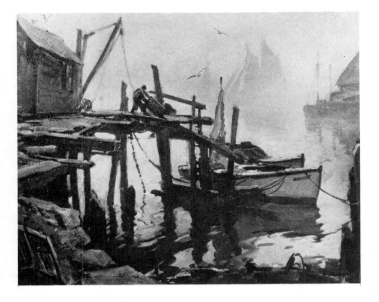

Low Tide and Lobsterman, oil on canvas, 30″ x 36″ (76 x 91 cm.). This is a picture of the things that go on under a dock. I was interested in the pilings, their angles, and the spaces between them. There's one big space under the dock—that's where the eye feels it can escape into the background. Notice that in the preceding picture we had light reflections surrounded by darks. Here we have dark reflections surrounded by lights.

Detail. The ocean bumping against the foreground mud makes the reflections more active than those in *Sailboats at Dusk.* The strokes for the reflections all zig-zag toward you. That gives them perspective and makes you feel the character of the water's surface. Notice how simply these reflections are handled. Students try to get in every subtle break in a reflection. It can't be done! Look instead for the general movement of the water and use a few strokes to suggest those characteristics. The piling nearest the boats leans to the right; the reflection — one dark squiggly stroke—leans in the opposite direction. The center piling is straight, so the reflection is straight, too.

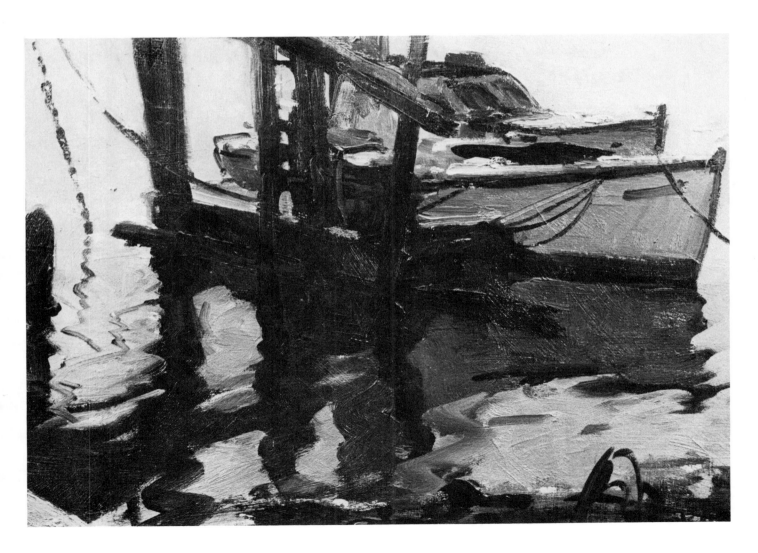

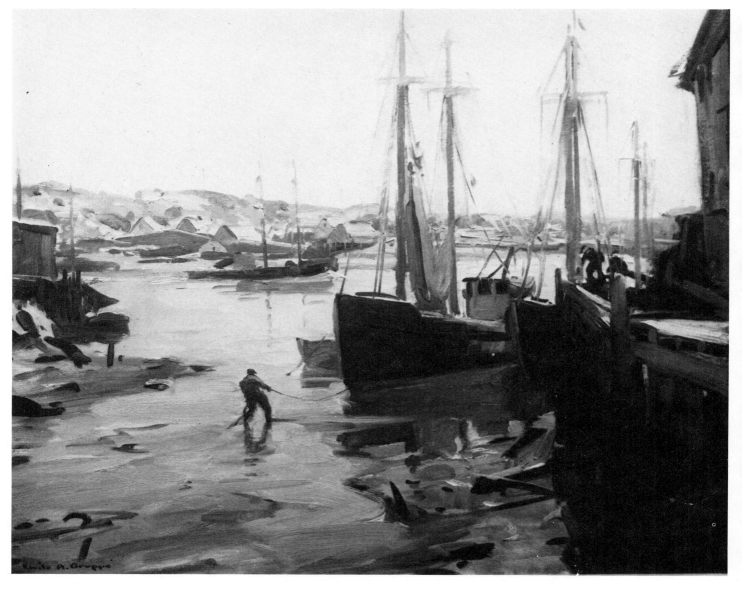

Low Tide, oil on canvas, 30" x 36" (76 x 91 cm.). Here I was interested in the way the wet mud caught the light and reflected the fisherman and the boat. The mud in the immediate foreground was beginning to dry and so is slightly darker than the area where water and land come together. That area catches a slight glare. The swirling strokes in the foreground lead you towards the dark figure of the man. His rope then pulls you into the rest of the design. The light stroke directly to the right of this figure is one of the most important in the picture. A ripple on the water, it breaks the dark reflection of the boat and gives you a clear sense of the surface of the harbor. Such strokes are always effective—but don't overdo them! The dark strokes in the foreground mud are also important. They represent junk and debris—but they're also good foreground accents. They emphasize the lightness of the mud, but their darkness also brings the foreground forward.

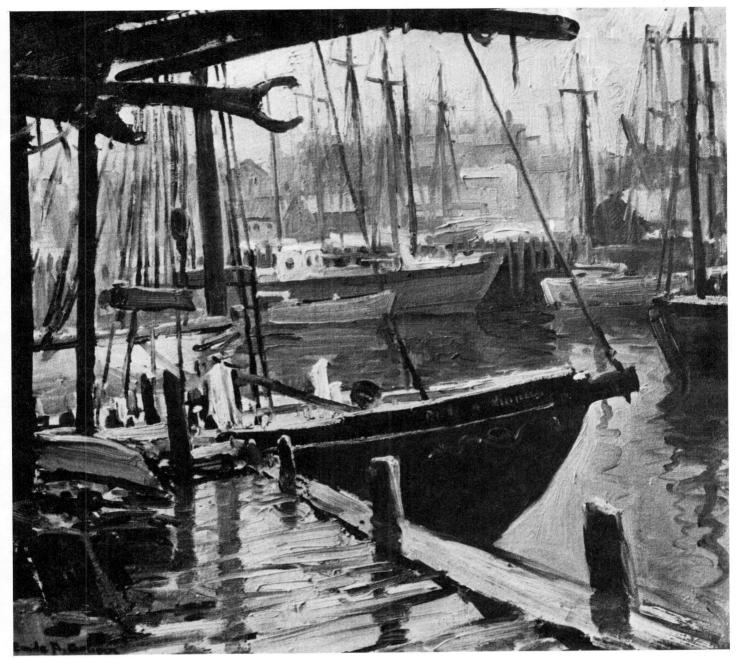

Painting in the Rain, oil on canvas, 18″ x 20″ (46 x 51 cm.). Here I painted a wharf during a heavy rainstorm. Since water kept running over the dock, it didn't have a chance to dry out. The reflections are thus unusually clear. The value of the wet wharf is actually lighter than the nearby water; it catches a light from the sky and has a sheen. To emphasize this sheen I've placed very dark shadows along the board that runs the length of the wharf. These dark strokes are larger in the foreground and smaller in the distance. The sheen is painted with diagonal strokes that parallel the direction of the boards themselves. As you move back along the wharf, these strokes become less pronounced. The reflections are a series of short, darker strokes, going in the same diagonal direction as the water. Occasionally some of the light color is pulled through a reflection, suggesting a break in the water's surface. The dock has just a skim on it, and there's little motion to the water—that's why the reflections are so straight. Overhead a few strokes suggest a roof. They make the viewer sense that he's protected. He feels comfortable.

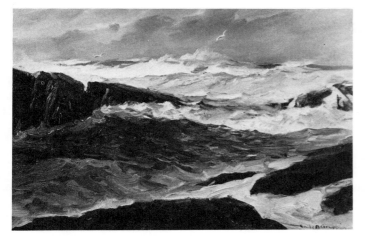

Offshore Wind, oil on canvas, 24" x 36" (61 x 91 cm.). I was interested in the contrast between the large, dramatic area of shadow and the smaller, livelier area of sunlit ocean.

Detail. Here you can see the two basic movements of the ocean water. Rhythmic, concave shapes are in the foreground; the water dances, building up into countless little peaks. In the background there's the contrasting, convex shape of the wave as it bulges and rolls over. Use your whole arm as you paint the convex movement of the waves; don't just make a series of jagged, disconnected strokes. Let one stroke flow rhythmically into another. Move the brush in a fluid motion. On the upper right part of the wave itself, heavy paint was applied first and then quickly brushed out, making it look as if the foam were blowing in the wind. It only took a couple of strokes—but the effect was better than if I'd spent all day working on it. The sky is kept simple and flat so that it doesn't detract from the texture of the water.

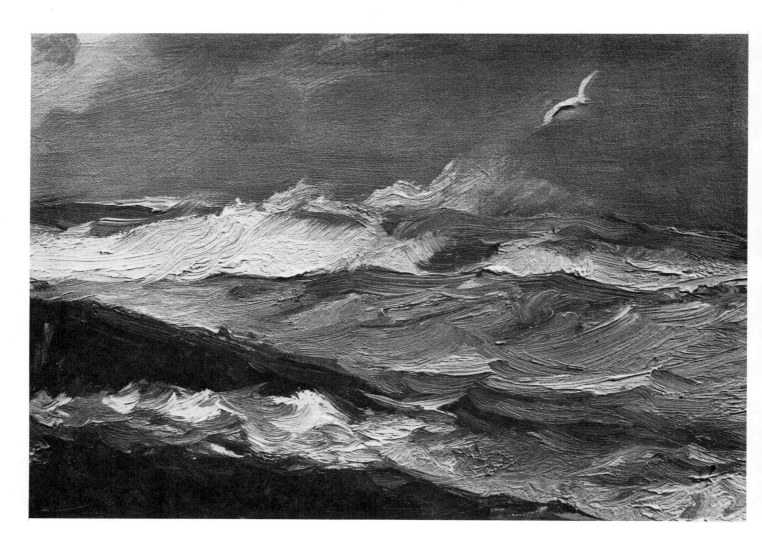

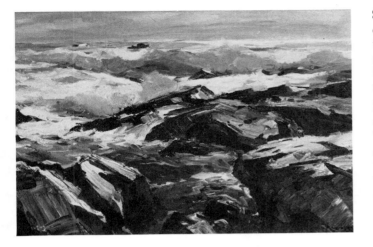

Surf and Rocks, oil on canvas, 20″ x 30″ (51 x 76 cm.), collection of the Cape Ann Savings Bank. In this picture the sun behind the waves throws a strong glare on the water. The waves themselves are thrown into shadow and become a series of dark, rhythmic shapes.

Detail. Protected by the surrounding rocks, this area of water isn't churned up and covered with foam. This is important: the dark water and darker rocks act as a large accent to the sunlit surf. On the left the strokes follow the downward movement of the water into the inlet. In the immediate foreground swirling strokes suggest the path of water around the rocks. This is an area of backwash; the water, having come into the inlet and hit the surrounding rocks, is moving out again. You can clearly see the place where it meets the opposing movement of the incoming tide. These swirling lines are, of course, further emphasized by the brusque, angular strokes of the nearby rocks.

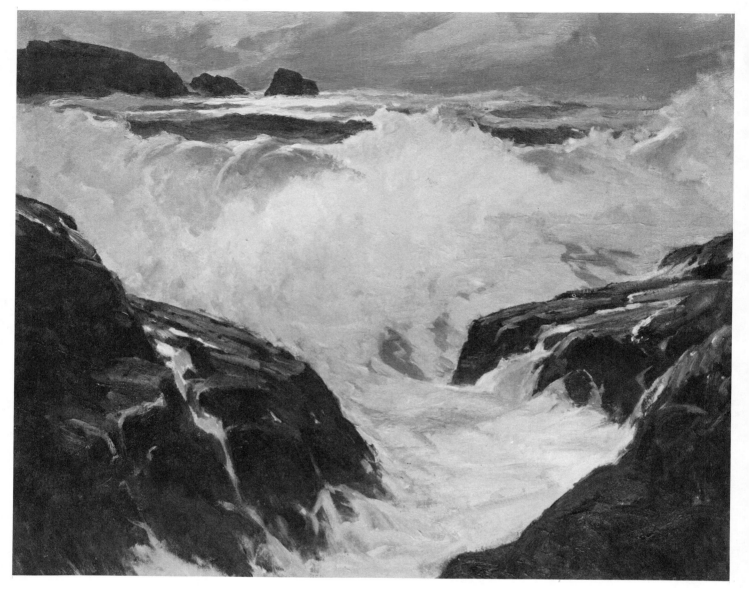

After the Storm, oil on canvas, 40" x 50" (102 x 127 cm.). When you paint water running off rocks, keep the individual streams to a minimum. Don't put in every one that you see; you'll confuse the viewer. You have to do what you did with your reflections: simplify. Just use the few trickles that best explain the planes of the rock. The foam and the huge foreground wave are all painted very simply; the strongly lit background has a chance to tell. A painting of this sort is dramatic—and people always like big waves. But I only half approve of them. In this picture, for example, the wave seems to stand still. It doesn't look as if it will ever turn over. Everything has suddenly come to a halt—like the sea in a photograph. And that's the one feeling you *don't* want in a marine! So I've included this painting as a warning. Remember: don't paint big waves because that's what everyone else does. Try to discover and express your own point of view.

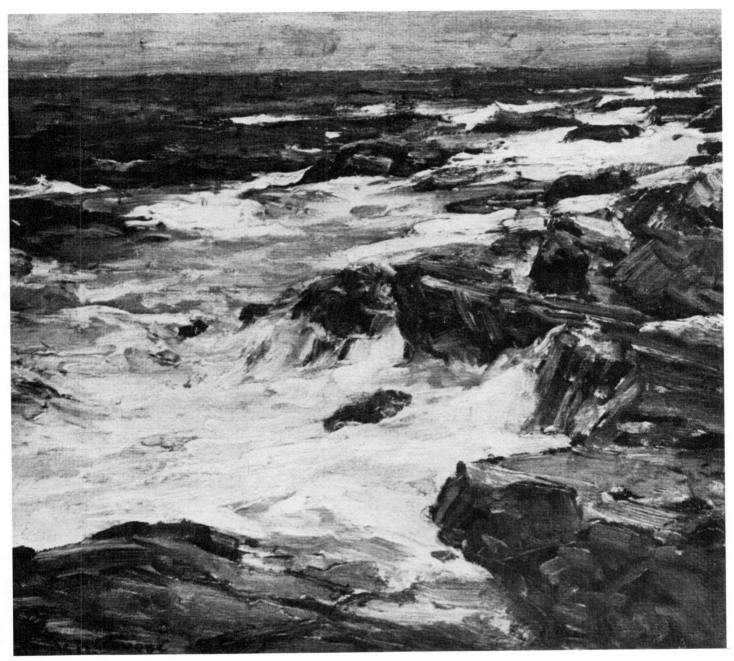

Rocky Shoreline, oil on canvas, 30″ x 32″ (76 x 81 cm.). I consider this a far more personal view of the ocean than the preceding picture. It's more to my taste because it tries to suggest the activity of the subject. It isn't static; the water splashes and spills all over the place. Both the rocks and the water are painted with lively strokes. The white water is done in big, sweeping, concave strokes — strokes that get bigger as they near the shore. Notice that in the distance, the foam becomes a few thin lines and dots. The rocks are done in short, staccato strokes, strokes that are straight and angular. They emphasize the water's rhythmic movement. Dark rocks are spotted all over the place. They add to the broken rhythm of the shore and, of course, explain all the white water. The dark rocks and the deep dark of the distant water frame the area of foam, emphasizing its brilliant whiteness.

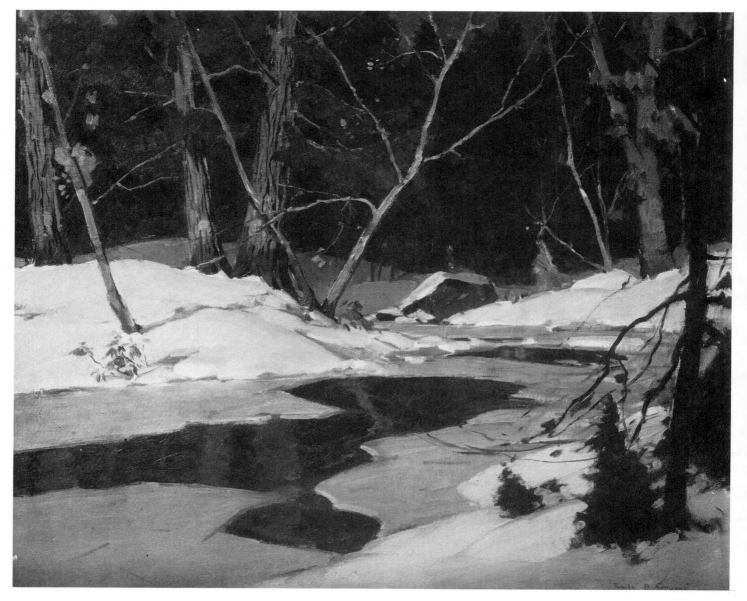

Wood Interior, oil on canvas, 40" x 50" (102 x 127 cm.). Deep in the woods I was moved by the overall peacefulness of the site. As a result I didn't use an active, heavy paint texture or a lot of boldly visible strokes. The snow masses are painted as large, convex shapes, and the water and ice are handled with a similar simplicity. A few dots of paint suggest the edges and bumps in the surface of the snow—they keep the flat areas from becoming too monotonous. Notice the swirling, rhythmic line created by the edge of the ice as it moves toward the foreground. That line is of major importance; it creates the perspective that pulls you into the picture. Notice also that the areas of water and ice in the foreground have a somewhat more noticeable texture than those at the distant turn in the river. Similarly, areas of open water nearest to us are large and angular in shape; the openings look smaller and flatter as they go into the distance. Taken as a whole, the simply painted foreground acts as a foil to the more active upper half of the picture.

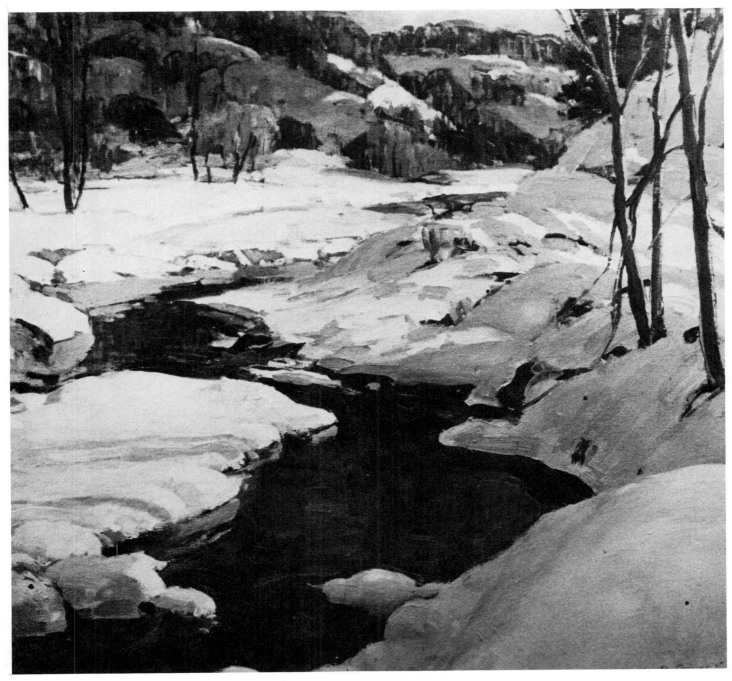

Snow Patterns, oil on canvas, 20″ x 22″ (51 x 56 cm.). This painting shows the same rhythmic movement of the water and the same convex snow shapes as in the previous picture — but the character of the site is completely different. We're in the open, and the sunlight is bouncing all over the place. Your eye feels the lively, broken texture of the scene. The shapes are big and simple in the foreground; but in the middle distance—where the light has full play—the strokes become much more active. In order to emphasize the dynamic quality of the site, the river is painted in a big, diagonal sweep. It swings way to the right, almost reaching the frame; then it goes sharply back, almost to the left side of the canvas. The river, hills, and snow banks all move horizontally. To break the monotony I've used contrasting vertical strokes in painting the water, the distant trees, and the tall trees to the right. These three trees weren't at the site — but the composition cried out for them.

THAWING ICE

Melting Snow, oil on canvas, 30″ x 36″ (76 x 91 cm.). On this warm, gray day the dark and light areas of wet and dry snow created a series of interesting patterns.

Detail. In the foreground one area is brushed right into another. They interact and create a variety of soft edges. This "softness" is characteristic of the day—you couldn't paint it with a lot of hard lines. Hard edges do appear in the distance, directly under the bridge. But, in reality, those places are soft and melting too. They're just so far away that you can't see the subtle transitions. When a hard edge appears in the foreground—a quick horizontal stroke or a dark squiggly line—it contrasts with the soft quality of the surroundings and so emphasizes it. The foreground is broadly painted. You're looking down on it and everything is big. In the distance you're able to see a wider area of the stream, and as a result, there's more activity in the brushstrokes. Remember to keep your activity toward the focal point of the composition.

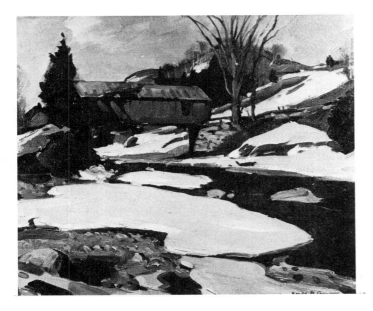

Bright Day, oil on canvas, 25" x 30" (64 x 76 cm.). I was attracted to this site by the pattern of the light snow and the dark water and fir trees.

Detail. In contrast to the preceding painting, everything here is sharp and crisp. It was a bright, cold day; nothing was melting. The snow itself is painted in broad planes. The upright sides of the snow are brighter than the tops — they catch a more direct light from the low afternoon sun. The smooth expanses of snow are in contrast to the uncovered areas of ground, which are richly textured. Notice, for example, the round globs of paint that indicate rocks and pebbles. The strokes in the immediate foreground curve up and into the picture. They're pointers, directing the eye toward the ice and the covered bridge. The dots of snow in the upper center of the detail add variety to the edge of the neighboring snow bank. They catch the eye and keep it from shooting too rapidly down the bank and out the lower right side of the picture.

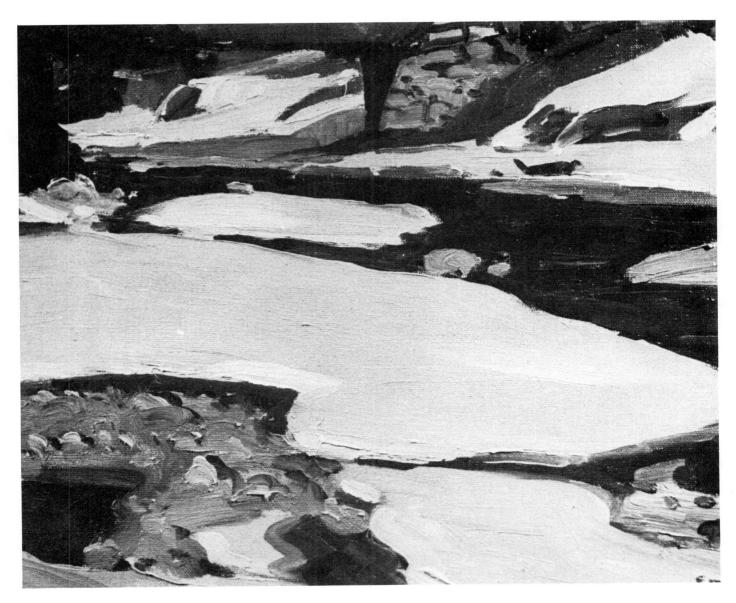

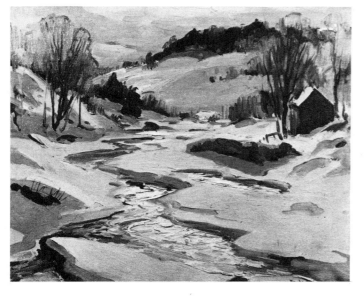

Sunlight on the Stream, oil on canvas, 20″ x 24″ (51 x 61 cm.). Searching for a subject, I looked down a riverbed and saw how the rapidly moving water caught a strong glare from the sun. The effect was so striking that I had to paint it.

Detail. The stream is heavily painted, and you can see how the energetic strokes suggest the water's swirling motion. A few dark lines emphasize this zig-zag movement. In addition, the dark strokes near the center accentuate the glare. The brilliant spot would be lost without those strong accents. Notice that all the water texture is in the foreground. In the back, directly beneath the fir trees, there's another spot of open water—but it's just a stroke of light color. The areas of snow are all painted very flatly. The foreground snow is similar to the snow in the distance. Very little happens in it, and it doesn't detract from the heavy impasto of the river itself. The glare on the stream is so bright that the water is actually lighter than the snow. The snow still looks bright, however, because it's contrasted to the intense darks of the nearby firs, rocks, and building.

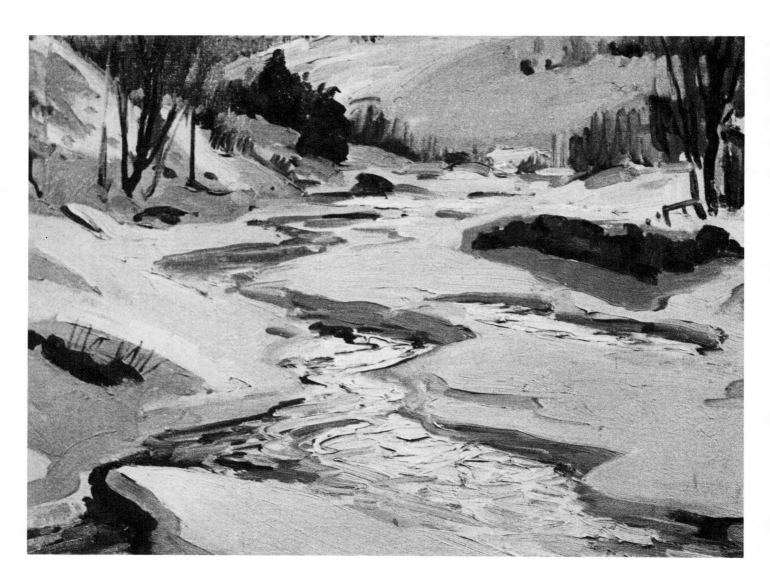

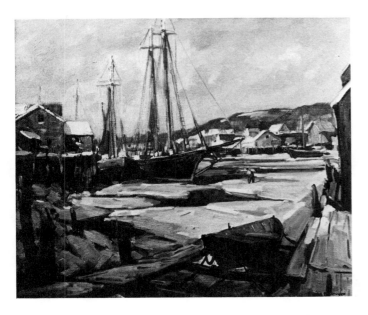

Frozen Harbor, oil on canvas, 30″ x 36″ (76 x 91 cm.). The tides constantly break and crack the ice that forms on top of a harbor. Here I was interested in the way these sharp, angular shapes work their way across the foreground.

Detail. On the left of the detail the ocean has washed ashore heaps of broken harbor ice. The broken pieces are painted with sharp, angular strokes; the strokes go in different directions, suggesting a random pile-up. Towards the center of the harbor, the ice is broken by dark areas of water. There's a large, angular area of open water on the left, and thin, dark strokes connect it to the water in the distance. These strokes suggest edges and rifts in the ice while also leading you into the composition. In the upper right corner similar cracks appear in the ice. They're so far away that perspective flattens out their angular sides. It's the same effect we saw in *Wood Interior*, (Page 72). Notice that the corrugated saltwater ice is nowhere near as bright as the snow on the roofs of the nearby houses.

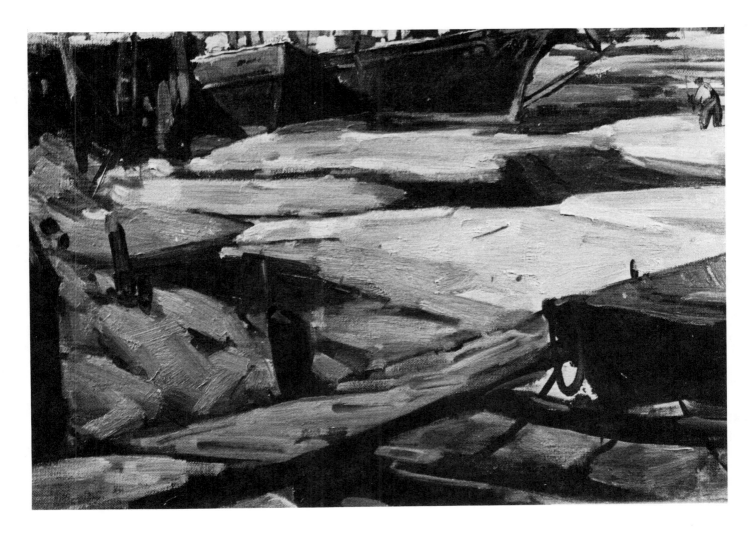

Rooftops, oil on canvas, 25" x 30" (64 x 76 cm.). In this painting I liked the interesting, abstract pattern formed by the roofs of the farm buildings. The snow on the peaked roofs is painted in flat masses, emphasizing their crisp, geometric shape. The snow on the flat-roofed hen houses, however, is painted with a rounded stroke. The snow was able to pile up on these roofs. A similarly rounded edge occurs where the snow swirls around the hen houses. Compare these soft edges to those of the house at the far right. There, everything is sharply painted; the sunlit edge of the house, for example, is one crisp, strong stroke. The foreground fence had to be painted so the viewer could see it—but wouldn't start counting each post. The posts are of different sizes and lean in different directions. Some are joined together, while to the left a few connect with the farm building itself. The posts in the foreground are large and dark. Those in the distance are just dots of white paint.

Winter Stream, oil on canvas, 16″ x 20″ (41 x 51 cm.). In this painting of a Vermont stream in March, all the strokes follow the lay of the land. In the immediate foreground big, loaded strokes suggest snow lying among the rocks. Smaller strokes suggest the flowing water, each stroke describing an individual rivulet—large areas of white represent the spots where rapids churn the water into foam. Thin, dark lines along the river's edge accentuate its downward movement. On the bank opposite us, the snow and dirt are painted with slanting strokes; the movement of the snow counterpoints that of the water. The background hills are more thinly painted, while the sky is almost textureless. The quick, upright strokes of the trees again relieve the back-and-forth movement of the snow masses. Notice how the land bulges in the distance. Directly behind the bridge there's one big convex hill. Against the sky there are five convex bulges—with a *mountain* visible to the far left! These changes in size add depth to the painting.

COLOR GALLERY

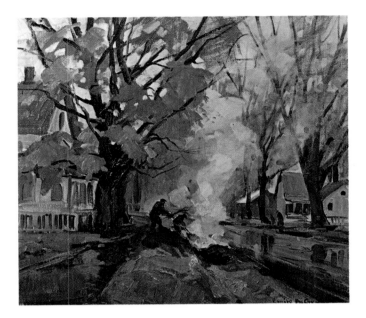

Burning Leaves, oil on canvas, 18″ x 20″ (46 x 51 cm.). It had just rained, and the wet leaves sent up billows of smoke as they burned. After the cold drizzle, it was *nice* to see a fire. The smoke also worked well in the composition—it was a cool mass that accented and relieved the warm yellows and oranges of the fall foliage.

Detail. A thin skim of water is on the wet road. There isn't any wiggle in the reflections; they come straight toward us. I've indicated the movement of the road by diagonal strokes—a movement that's crisply broken by the vertical reflections. A few thin, dark lines suggest breaks in the road's surface. Notice how thinly the background is painted. In the immediate foreground, a few heavy strokes suggest individual leaves lying in the road. In the distance, the masses of foliage are stained on the canvas—and are less brilliantly colored than those nearer to us. Notice also the perspective in the group of trees to the right. The closest tree is composed of a number of wide brushstrokes. The one behind that is only a single stroke thick. And the one behind that is even thinner and less defined.

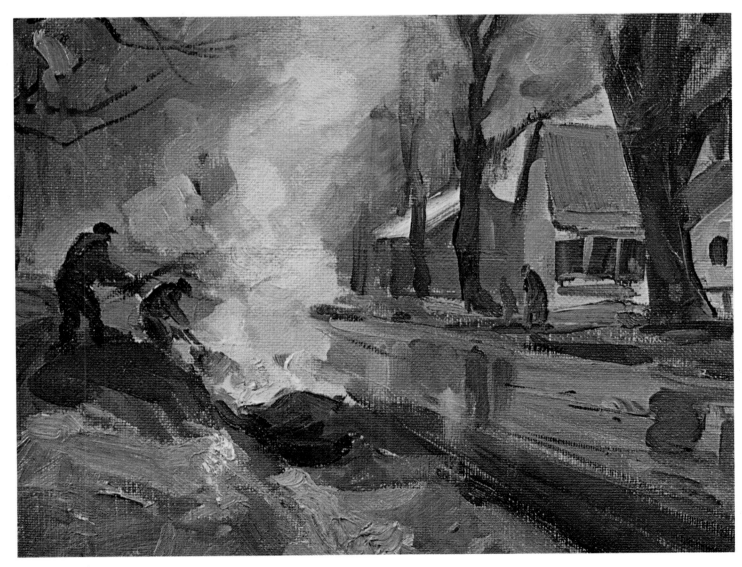

BUILDINGS IN FOREGROUND

Waterville Bridge, oil on canvas, 30" x 36" (76 x 91 cm.). In order to emphasize the feeling of looking down on the town and the bridge, I kept the foreground buildings low and the horizon high. You see a lot of roofs and sense that you must be standing on a hill. The picture is a study of the way various roof lines oppose and accent one another.

Detail. The bridge is in the immediate foreground, and you can see the individual boards that make it up (you don't see such details as clearly in the distant houses). Each stroke represents an individual board; an occasional dark suggests a crack or hole. Since the front of the bridge catches a strong blast of light, it was first painted with warm color (you can see some of the red-orange underpainting showing through). Then, cool, complementary green was added, partially neutralizing the underpainting and giving it a grayish look. Both the covered bridge and the nearby tree have a slightly greenish cast, contrasting effectively with the warm rusty red of the bridge's roof. Notice that the distant foliage is painted as a mass of color. Only in the foreground do you see bright orange individual leaves.

BUILDINGS IN MIDDLE DISTANCE

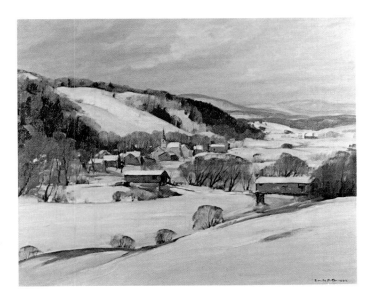

Town of Cambridge, oil on canvas, 30" x 36" (76 x 91 cm.). This view of Cambridge, Vermont, was painted before its unique twin set of covered bridges was replaced by a single iron span.

Detail. The distant buildings are all painted as an interconnected group, with no one building standing in isolation. A few horizontal and vertical strokes tell the story. Windows are merely small dots—just a few, in order to make my point without confusing the picture. A few short, dark shadow strokes accent the sunlit sides of the buildings and tell you the direction of the light. Behind these buildings, the trees are so far away that they become a simple mass; they're a design rather than a collection of individual maples and evergreens. Here and there, a dark stroke suggests a trunk. The tree mass accents the snow-covered roofs of the nearby houses. The dark tree directly above the covered bridge also brings out its light roof—and connects the bridge to the buildings in the background. The snow on the roofs is lighter than that on the ground; it's at an angle and so catches more of the sun's rays.

BUILDINGS IN DISTANCE

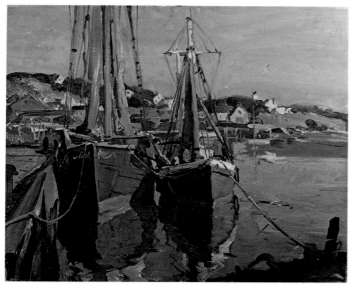

At Dock, oil on canvas, 25" x 30" (64 x 76 cm.). In this picture, I wanted to emphasize the size of the boat nearest the dock. I ran its mast out of the picture while keeping that of the other boat inside the design. The mast inside explains the one beyond the canvas and lets you gauge how tall it must be.

Detail. On a clear day, late in the afternoon, the low-lying sun throws a brilliant light on the distant houses—they stand out sharply. The trees are also crisp and dark. In the distance, we see textures rather than objects. The sailboat is a horizontal stroke; the pilings, a few upright lines; the reflections, a few quick slashes. The largest building has a visible window. Higher up the hill, however, the buildings are so far away that you can't see the individual windows. Notice how the characteristically sharp, angular shapes of the houses are contrasted with the rounded shapes of the nearby trees. The field of yellow grass has been neutralized by the atmosphere; much of the warm yellow that you'd see if the grass were at your feet has been weakened by cool veils of air hanging between the grass and us.

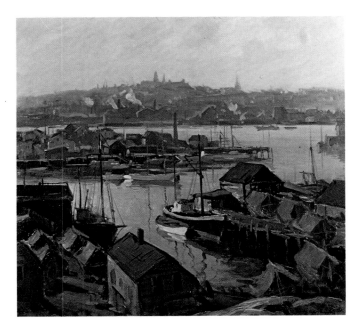

Panorama of Gloucester, oil on canvas, 30" x 32" (76 x 81 cm.). The day was hazy and thus gave a great feeling of distance to the scene. I redesigned the foreground nets to point you into the picture and step you up to the sunlit dragger and seine boat. The dark building on the left contrasts with and accents the bright building on the right. Together, they add breadth to the foreground.

Detail. In the far distance, the atmosphere pulls all the buildings and trees into a large, cool mass. It's important to hold this mass as a unit. The viewer sees it—but isn't distracted from the rest of the picture. I brushed it in with a few big, horizontal strokes, and then cut into it with some thin vertical and diagonal lines. The strokes represent the sides and roofs of buildings catching the light. Steam from the gas works adds vitality and interest to the area— you feel you're looking at a living city, not a ghost town. A few dark upright strokes suggest chimneys.

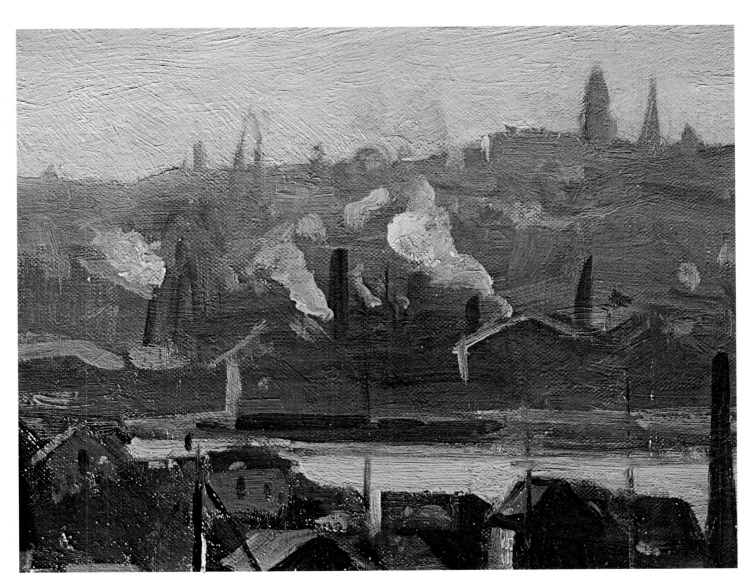

ROCKS ON A BEACH

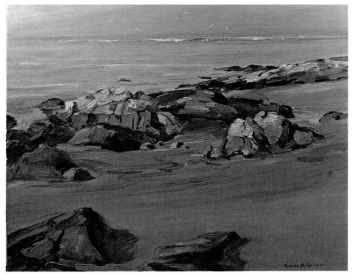

Wingaersheek Beach, oil on canvas, 25" x 30" (64 x 76 cm.). Here I was interested in the way the rocks, at low tide, slowly snake their way into the distance. Rocks and a wet beach are clearly the subjects of this picture—the water and distant waves are subordinate elements.

Detail. The ocean has the greatest abrasive effect on the lower parts of the rocks. These parts are therefore the smoothest. You can see how curved strokes suggest their rounded shapes. The sea stains them, so they're also darker than the upper parts of the rocks, which are usually above water so the sun has a bleaching effect on them. Since the rock juts up out of the beach, the paint is applied with heavy, vertical strokes. Occasional horizontal strokes create variety within the mass and suggest different planes of the rock. The sand is painted with broad horizontal strokes. This horizontal movement contrasts with that of the rocks and thus emphasizes their upward thrust. The beach is also an area of relatively flat color; it doesn't compete with the strongly colored and textured rocks.

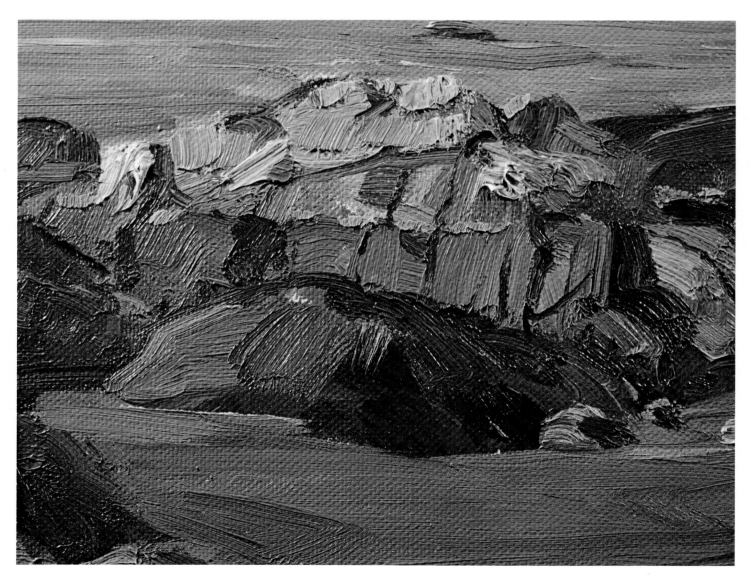

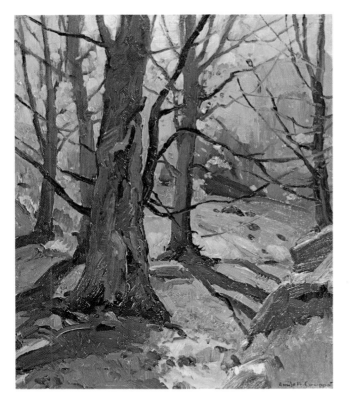

Fall Woods, oil on canvas, 20″ x 20″ (51 x 51 cm.). When you're inside the woods looking out into the sun, the light streaming toward you brilliantly lights up the foliage and turns the trees into dark silhouettes. The distance disappears under the strong glare.

Detail. The low, raking light hits each blade of grass and lights it like a lantern. The yellowish tufts seem to glow. The shadows cast by the trees are very dark and have a greenish tone. Shadows usually assume some of the complementary color of whatever they fall on. The eye tires of the brighter color and seeks relief by generating its complement in the shadow. In this case, the green contrasts with and accents the warm reds of the dead leaves and grass. To the sides, the large rocks are painted as dark, angular shapes. At the bottom and top of the detail, pebbles are suggested by a few rounded dots. The grass is indicated by both upright strokes (in the foreground where the strands of the brush suggest individual blades of grass) and flat strokes (in the background where, instead of seeing tufts of grass, you see the general lay of the land). A mass of curved strokes in the center of the detail suggests a pile of falling leaves.

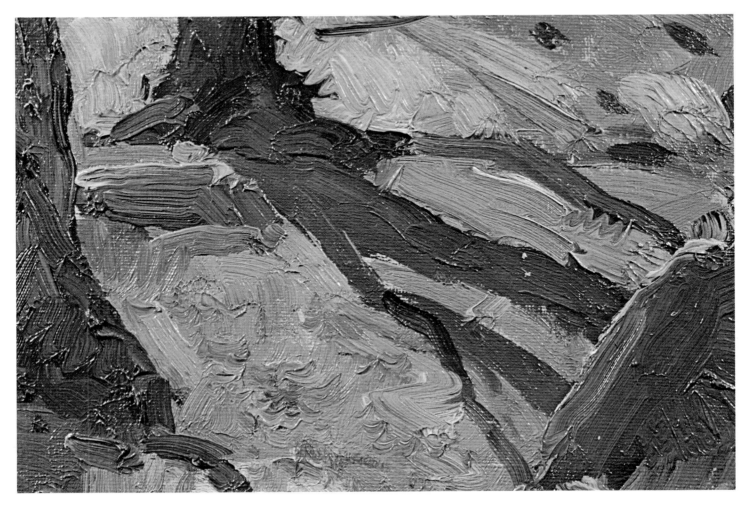

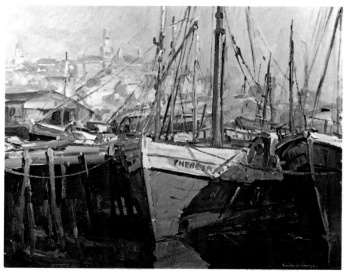

Boat Study, oil on canvas, 25" x 30" (64 x 76 cm.). Here I was struck by the relationship between the large green boat and the contrasting red one. Since the main boat is huge—its gunwale is above the wharf even at low tide—I pulled its mast out of the picture. The foreground rigging forms a screen; you look through it to the hazy but brilliantly lit buildings in the background.

Detail. In this extreme close-up, you can see how easy it is to suggest a very complicated mass of equipment if you only learn to think in terms of *textures*. I've suggested winches, pulleys, dragger doors, and a distant dory—all by a few quick, sharp strokes. The eye sees an angular, busy texture and imagines the equipment much better than you could ever paint it. At the center of the detail, I've suggested a rusty area by a similar series of diagonal and horizontal strokes. Remember: put down the dots and dashes that you see — the upright and slanting lines, the hard and soft edges. Get the visual sensation down on canvas, and the viewer won't have to be shown every nut and bolt.

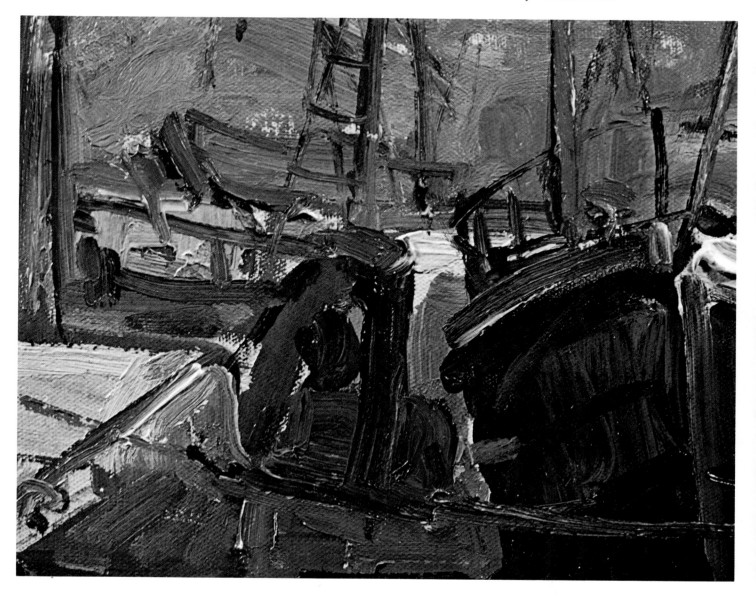

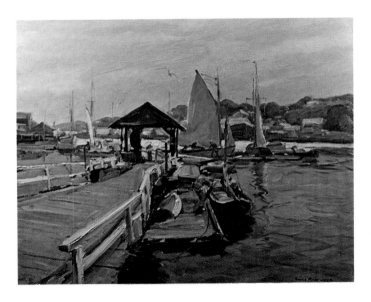

Floating Dock, oil on canvas, 25" x 30" (64 x 76 cm.). I kept the walkway and the floats to the left, so I'd have room on the right for the sailboats and figures. Notice how the wharf, floats, and foreground boats all point powerfully into the picture.

Detail. The sun is behind the boats and casts a glare on the water. The sun shines through the large sail, giving it a warm glow. I painted it by putting this warm color down first; then I added the cooler color reflected onto it by the sky. Notice how each stroke in the sail follows a particular bulge or droop in the material. I drew the basic rigging lines—but let the rest go. From so far away, you can't see each pulley and rope. The small figures add activity to the scene and help scale the boats. The background buildings were painted as a large mass, broken by a few light roofs (the sides of the houses are all in shadow). The distant foliage is all rounded at the top; you can't see subtle variations at half a mile. The warm color of the sky reflects darker in the water. This water mass was painted flatly—a few dark strokes were then added to suggest ripples.

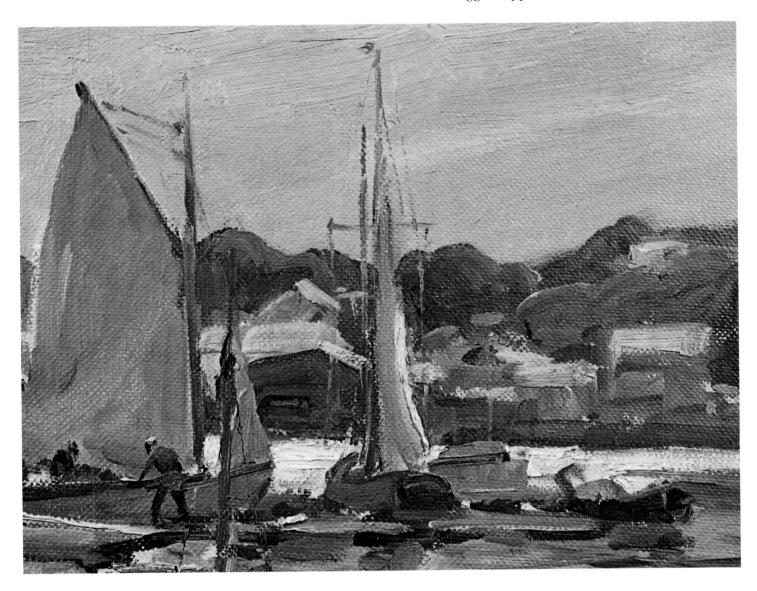

Spring: Blossoms and Weeping Willows, oil on canvas, 25″ x 30″ (64 x 76 cm.). I wanted to get the feeling of the season: the foliage was a delicate yellow-green, and the lilac and apple trees were in full bloom.

Detail. There's a lot of green in this picture. It needed a spot of red as a relief for the eye; so I dressed my figure in a red blouse. Notice how the figure is a *part* of the surroundings. First of all, it's doing something. The viewer doesn't know exactly what, but at least it has a reason for being where it is. The figure is also painted in a way that's similar to the rest of the picture. The sketchy handling of the trees and houses is matched by the curving stroke of the figure's shoulders and arm, the dot of the head, and the quick, vertical stroke of the dress. The legs of the figure disappear into the shadow of the hedge; they hook onto something. Notice the contrast between the crisply angular stone fence and house and the curved and rounded rhythms of the trees, plants, and figure. One movement accents the other.

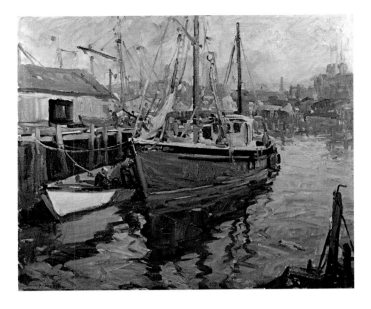

The Green Boat, oil on canvas, 25" x 30" (64 x 76 cm.). I was drawn to this site by the interesting relation of the white boat to the white sail. One shape echoes the line of the other, creating a swooping movement upward to the right. This line counterpoints the line of the gunwale of the fishing boat—which swings upward to the left.

Detail. This detail shows two ways to handle figures. The foreground men are near to us and are painted with a certain amount of detail. You can even see their red, tanned arms and heads; a white dot suggests a cap. The figures are tied together by a dark shadow and function as a unit. The worker on the wharf is much smaller; he helps give a feeling of recession to the design. The upper part of his body is a simple dark spot, with a smaller spot for the head. Arms and legs on all figures are quick strokes that follow the movement of the body. In a similar way, diagonal strokes describe the boards on the side of the green boat. A thick, concave stroke represents the hanging sail, and crisp, upright strokes suggest pilings and masts.

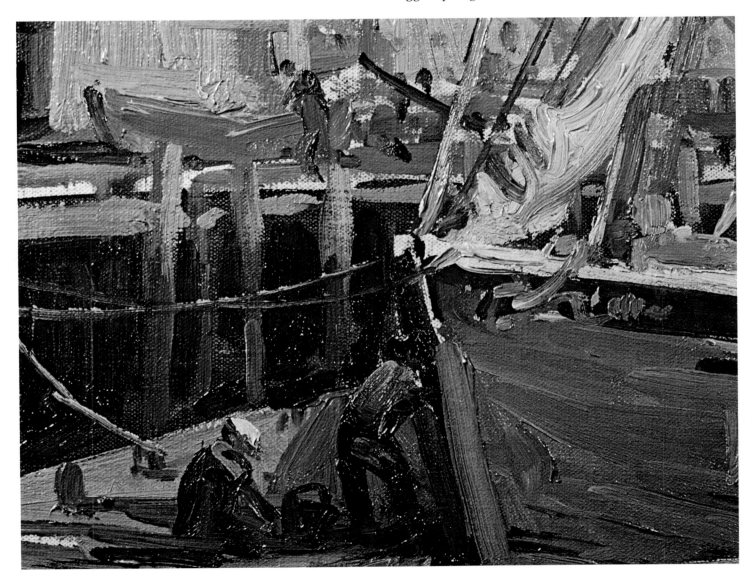

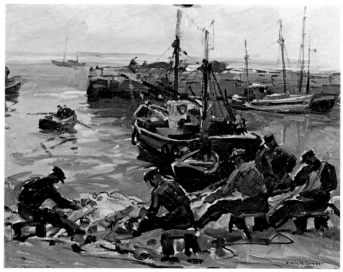

Fishermen, oil on canvas, 16" x 20" (41 x 51 cm.). In this quick sketch, I was mainly interested in the way the workers clustered around the net. I tried to get as much variety as possible in their poses.

Detail. I've interconnected the workers so that they register as a unit. I've given the group a focus by emphasizing one principal figure. He's slightly bigger than the others, is dressed more vividly, and is placed against the dark background of the boat and the worker in the green shirt. The green shirt acts as a relief to all the red in the foreground. The men are "drawn" with masses of color. A hand is one spot of paint, a head another. The deep red color suggests their heavily tanned complexions. Here and there, a stroke suggests a pattern on the shirt, while a dark accent brings out the line of a leg or an arm. The small dory next to the background boat is an important element in the design. It scales the larger boat, telling you how far away it is.

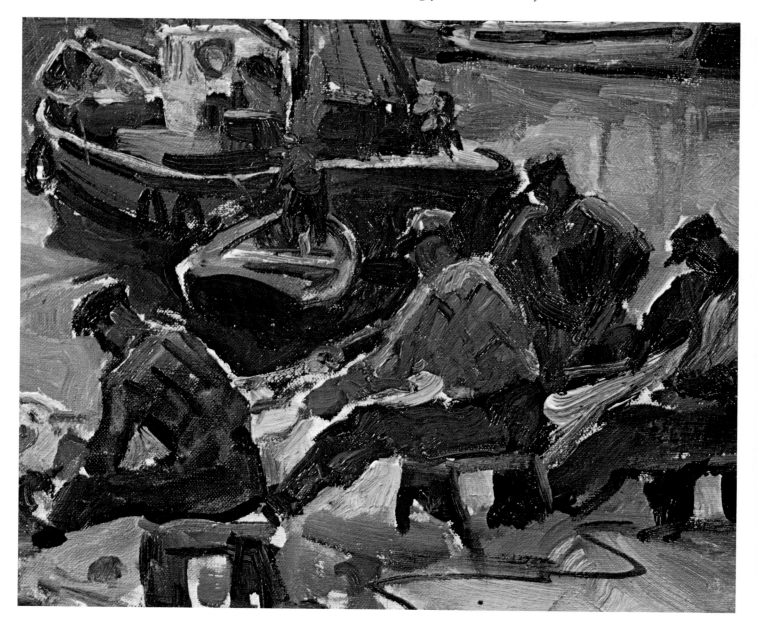

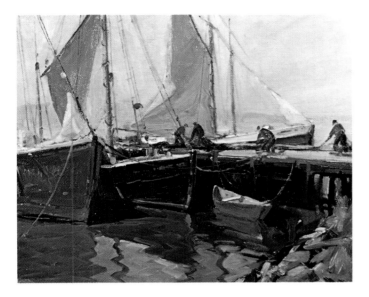

Drying the Sails, oil on canvas, 25" x 30" (64 x 76 cm.). This is a foreground picture. There's very little distance—just a suggestion of a hazy, blue landfall. Since the boats are large and very close to us, the masts all go out of the picture. Notice how the movements of the sails counterpoint each other — one hangs down, while the other angles upward.

Detail. Although one boat is green and the other black, the sunlight is so strong that the dust and dirt in the water catch a glare, giving all the reflections the same warm, green color. The reflections are painted with strokes that zig-zag toward us; they clearly define the surface of the water. The reflections start fairly straight; but as they near us, we can see more of the water's effect on them, and they take on a pronounced wiggle. The strong sun also casts the shadows of the boats on the water. Long ropes tie the boats to the wharf and give the viewer a feeling of security — he doesn't feel they might suddenly float away.

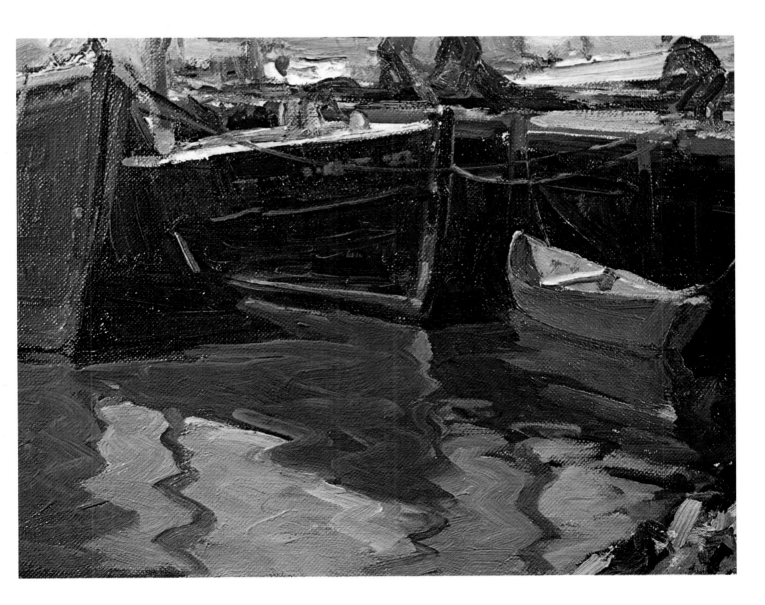

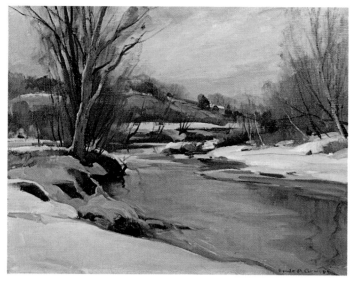

Evening Light, oil on canvas, 20″ x 24″ (51 x 61 cm.). At the site, I especially liked the way the stream reflected the delicate, warm color of the afternoon sky. The edges of the snow catch a strong highlight from the low afternoon sun.

Detail. The warmth of the sky and the water contrasts with the shadows on the snow and makes them look very cool. You can see how blue they appear. In the background, the bank and hill were first stained with a warm color—you can see the tooth of the canvas through it. Here and there, a number of more loaded, curving blue strokes were pulled over this underpainting. Each stroke describes a patch of snow. The distant trees are suggested by a broad stain (really an extension of the color used to block in the background hill). A few dark and light lines suggest trunks of trees. Notice how dark accents in the distance (evergreens) break the line of the hill; they prevent the eye from moving down it too rapidly. They also scale the area—you know from the size of the pines that you're looking at a hill, not a mountain.

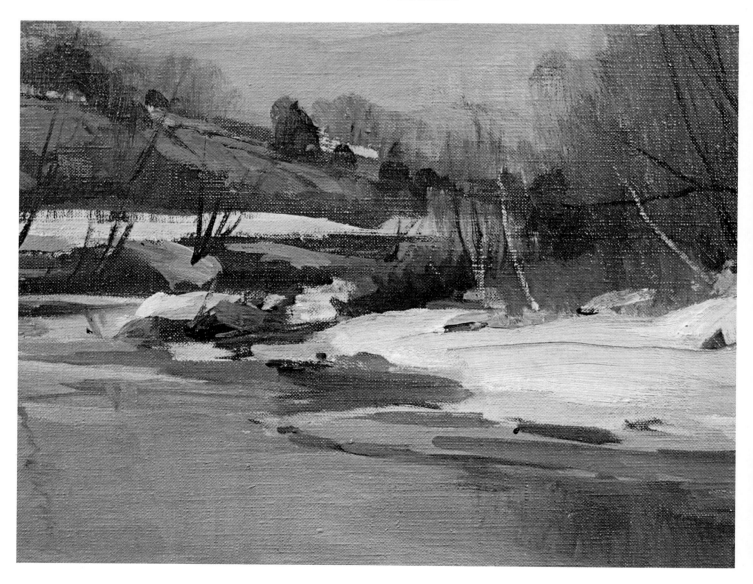

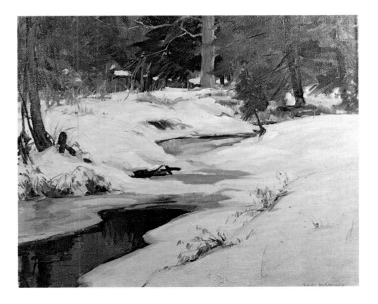

Frozen Stream, oil on canvas, 25″ x 30″ (64 x 76 cm.). I especially liked the way the stream zig-zagged into the picture. In contrast to *Evening Light*, this is a grey day, with no strong highlights or shadows.

Detail. Lacking strong shadows to model it, the snow is flatly and simply handled. The strokes move horizontally along the top of the bank and diagonally down the sides. They blur with the ice near the stream, creating a soft edge that's appropriate to the melting quality of the day. Snow has blown across the center of the stream, forming a drift on top of the ice. Details like this are *true* — they have to be seen and painted outdoors, because you'd never imagine them in the studio. In the foreground, a few strokes suggest stems and leaves of dormant plants. You don't have to show where each leaf joins the stem; if you did that, the clumps would attract too much attention. The foreground pool is a still, dark accent which, by contrast, emphasizes the whiteness of the surrounding snow.

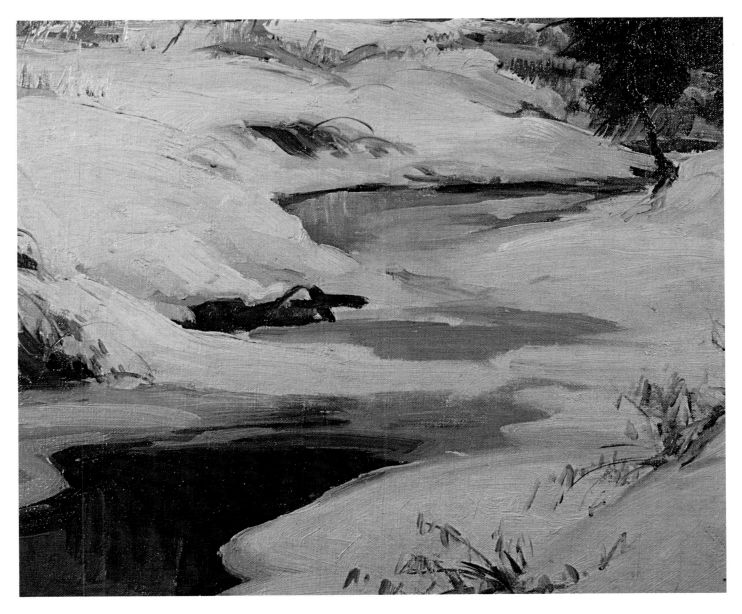

SUNFLOWERS

My Sunflowers, oil on canvas, 20″ x 24″ (51 x 61 cm.). This picture was painted in my own backyard. I've always liked the lively way Van Gogh handled such subjects—so I decided to try it myself!

Detail. Only one main flower—the one at the lower left of this closeup—is done in detail. Each petal is a single stroke. The other sunflowers are smaller and are painted in a broader manner. The blossoms in the upper right, for example, are just a few big strokes. There's a variety of color in all the flowers— they're not only yellow, but have touches of orange and even green (reflected into them from the nearby leaves). The flowers face in different directions, so you see the backs of some and the sides and fronts of others. They swing back and forth, moving toward and away from one another. That's how sunflowers naturally grow—their heavy blossoms weighing on the stems and bending them. Notice that I don't show every stem; a few tell the story.

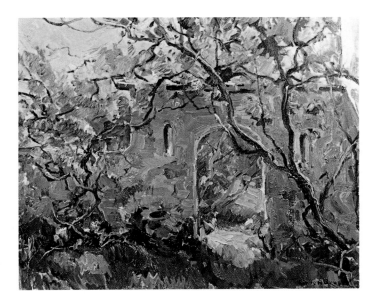

The Gateway, oil on canvas, 25″ x 30″ (64 x 76 cm.). I've painted this gate from both the front and the back. From the front, you can emphasize the texture of the sunlit stucco and the shadows cast by the wisteria on the wall. From the back, shown here, you can study the shadows and the way the sun lights up the leaves and blossoms. The gate also is especially inviting — the viewer sees the warm color beyond and wants to walk into the picture.

Detail. Lit from the back, the leaves have a brilliant, warm glow — at points, they become so bright that they almost merge into the sky. The tops of the wisteria catch a light, while the rest of them remain dark in shadow. Because of their small size, it's impossible to paint wisteria blossoms one by one; they have to be painted as a mass. "Drawing" isn't of prime importance here. The whole picture is an exercise in color and texture. A series of rapid, small squiggles represents the delicate character of the wisteria, while broad, opposing strokes suggest the rougher surface of the stuccoed gate. Thin, swirling lines suggest the angular movement of the wisteria vine. These lines also help connect the different masses of foliage.

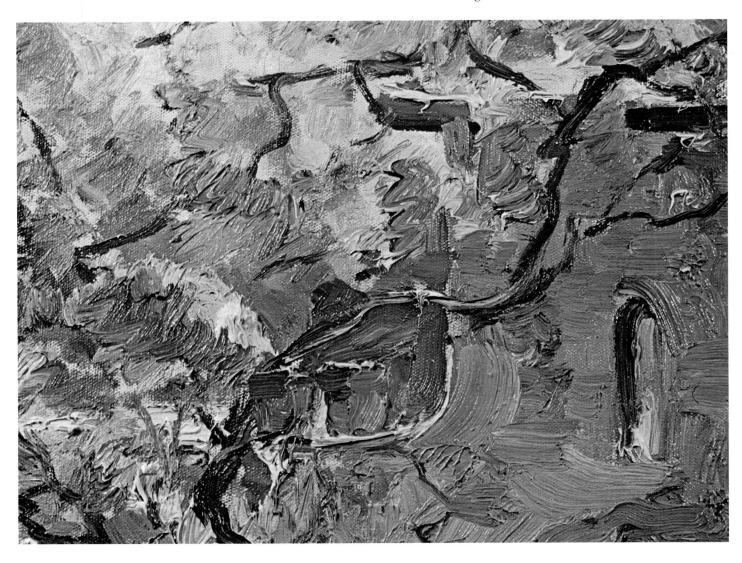

BARE BRANCHES

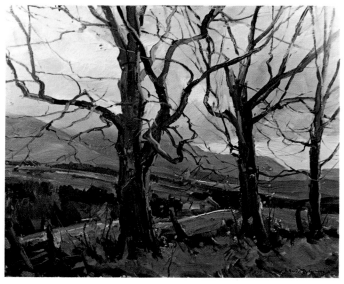

Maple Trees, oil on canvas, 25" x 30" (64 x 76 cm.). I liked the pattern the dark trees made against the gray, overcast sky. There's one principal tree — the one nearest us. The other trees get smaller as they recede. The branches of the foreground tree run far to the left and the right, tying the picture together.

Detail. The broken trunk in the center of this detail gave me an interesting yellow spot in the sky. I also had the problem of making the trunk *look* broken — not as easy a trick as you might think. Notice the way the branches move. Each is about a brushstroke thick. And since they're against a light sky, they have to be drawn right — the first time! They're not stuck into the sides of the trees; they widen as they near the trunk. They start fairly straight — then swerve and swirl in an attempt to find a path to the sun. Some branches move to the side; some try to go straight up. Others head in one direction, find the way blocked by heavy foliage, and then shoot off along a completely different path. Properly considered this movement is not only dramatic — it's also an expression of the tree's character and its history.

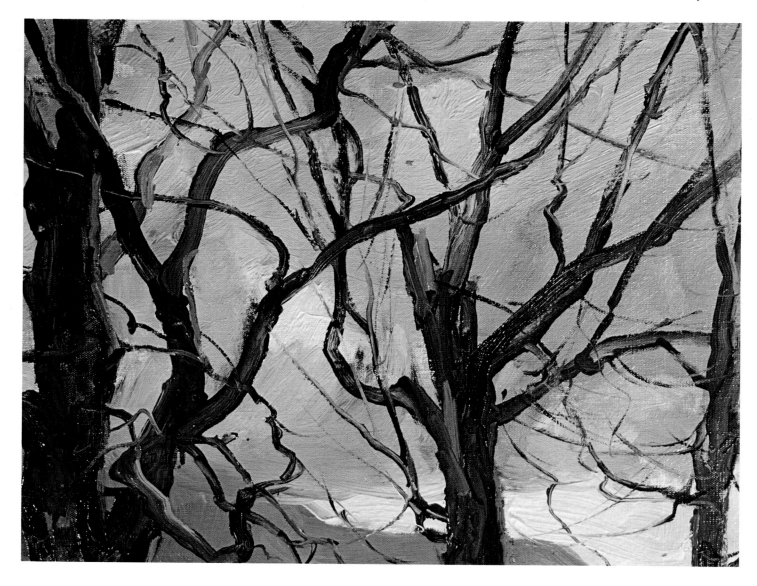

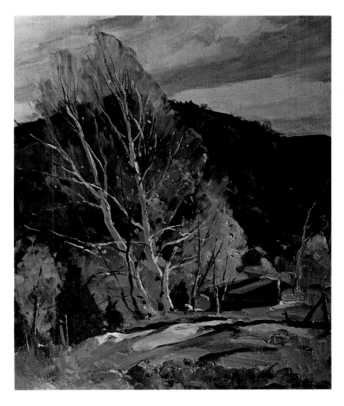

Chicken Coop and Birch Trees, oil on canvas, 25″ x 30″ (64 x 76 cm.). This picture emphasizes the contrast of the brilliantly lit fall foliage and the somber, dark mountain in the distance. The mountain was thrown into shadow by a passing cloud.

Detail. All outdoor color is *relative*. There's no such thing as a "recipe" for rocks and grass—everything depends on the character of the day and the amount and quality of the reflected light. The shadow side of a birch tree tends to be cool; but in this scene the powerful yellow and orange foliage reflected its warmth into the birches' shadows, turning them green. Notice the different ways the shadowed and sunlit areas are handled. The trunks of the trees and the darks directly behind them are both thinly stained —that gives them a certain transparency. The highlights on the trunk, however, are all painted thickly. I made sure the viewer can see them. The paint thickness also increases as the fall foliage catches the light. Notice that the background foliage is all painted as a mass; no individual leaves stand out.

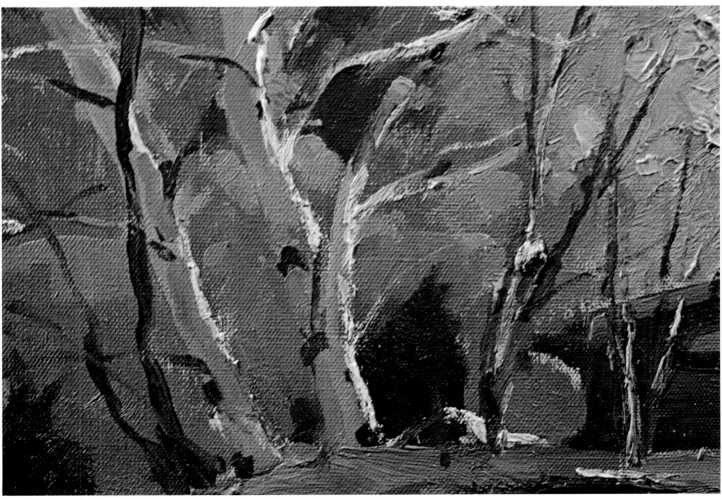

APPLES

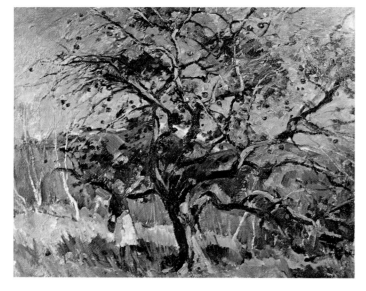

Don't Sit under the Apple Tree with Anyone Else but Me, oil on canvas, 25" x 30" (64 x 76 cm.). I was interested in the angular movement of the apple tree's branches and in the little red spots made by the apples against the clumps of green leaves and the greenish sky. The tree was a screen through which I could see the distant fall foliage and the snow-covered peak of Mt. Mansfield.

Detail. The problem was to paint the tree without letting the picture break into a collection of red dots. In order to avoid that, I emphasized only a few apples — the ones to the right of center. They're the brightest and most detailed; a few even have little highlights on them! Each is painted with one stroke of the brush. The other apples are darker, and many of them are hooked onto the shadow parts of the tree. Fall is a perfect time to paint this kind of subject; the leaves have begun to drop, and you can see the anatomy of the tree. The remaining leaves are treated as areas of color — with only one or two leaves visible at the edge of the mass. The branches are crisp, dark strokes that break and twist in a way that's characteristic of the subject.

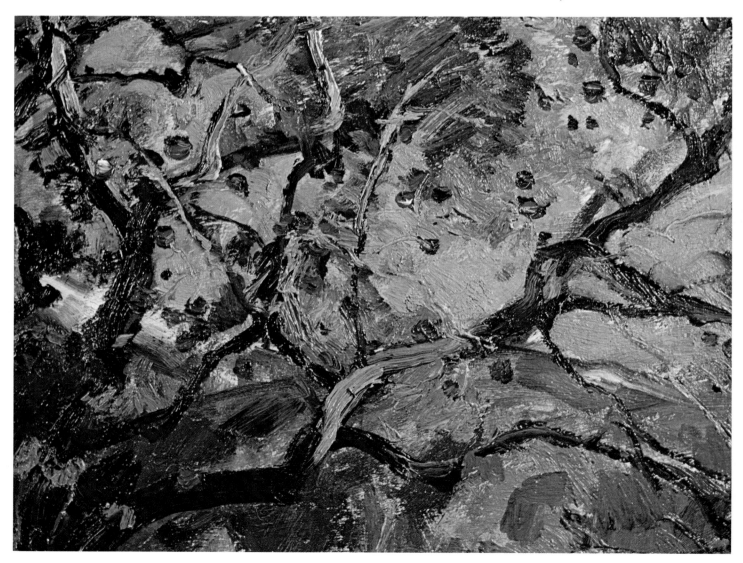

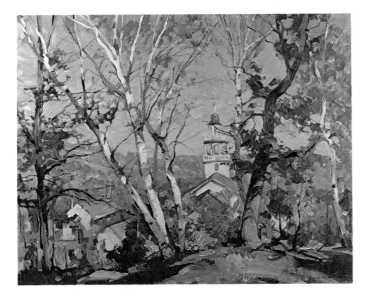

Hillside Birches, oil on canvas, 30″ x 36″ (76 x 91 cm.). I liked the way the distant church steeple peeked through the screen of birches and maples. The birches had lost most of their leaves. Characteristically, the maples still held on to most of their bright fall foliage.

Detail. Maple leaves are fairly dark. When painting such a mass, I first plan my leaf areas and then stain the appropriate parts of the canvas with a darkish tone. In the lower right corner of this detail, you can see where this original color, untouched, still shows through the heavier overpainting. I then paint in the sky, cutting the stained areas to size. Following this, I add heavier paint to the leaf masses, each stroke representing an individual leaf. Here I've kept most of the loaded areas toward the center of the stained sections. That way the impasto looks like nearby leaves, while the stain suggests clusters of leaves in the distance. Here and there, an individual leaf is painted into the sky. Notice how the leaves cast a dark shadow on the trunk of the tree—the shadow accents the leaves, making them pop out more crisply.

CLOUDY SKY

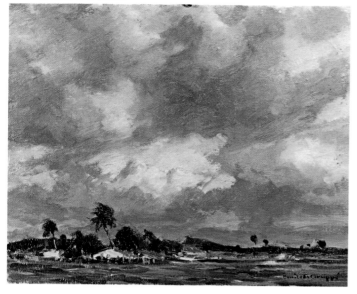

Florida Sky, oil on canvas, 20″ x 24″ (51 x 61 cm.). This is an example of the dramatic skies that you often find in Florida. Since the effect doesn't last long, I had to paint it very rapidly.

Detail. The warm light of the setting sun hits the fully exposed sides of the distant clouds, turning them a warm red. The small cloud near the horizon is almost carmine. These warm, reddish clouds are accented by the complementary green of the nearby sky. As the clouds come over head, we see less of their sides and more of their bases. In the upper half of the detail, the bases are a warm red-purple. They get darker as they go into the distance; the blue of the atmosphere also obscures the red, turning the color of the bases to a blue-purple. The edges of the background clouds are sharp and clear — you can't see any subtle, windblown areas. Overhead, however, the clouds are nearer, and you see where the wind diffuses the edges, making them soft and transparent.

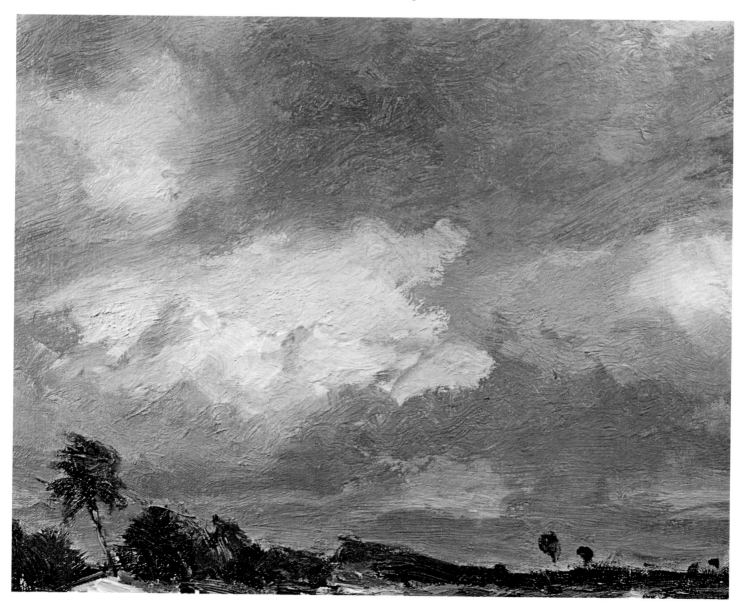

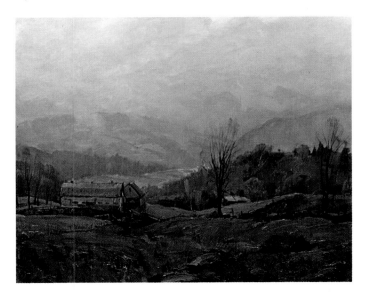

Foggy Day, Vermont, oil on canvas, 25″ x 30″ (64 x 76 cm.). Heavy clouds filled the valleys on this fall day, hiding most of the distant hills. The barn in the foreground gives scale to the picture, as do the foreground trees and the small house on the right.

Detail. In foggy weather, the values are always very close together. In this detail, for example, the distant mountains merge subtly into the hazy background. Light areas are pulled over the darker ones and blended with them. The trees are a blur — though within the mass you can still distinguish the maples from the pines (the latter are slightly darker and have a characteristic pointed shape). I've used thick paint where it counts — in the foreground of the complete picture. The heavily painted rocks and grass give, by contrast, a delicate and transparent look to the more thinly painted distance.

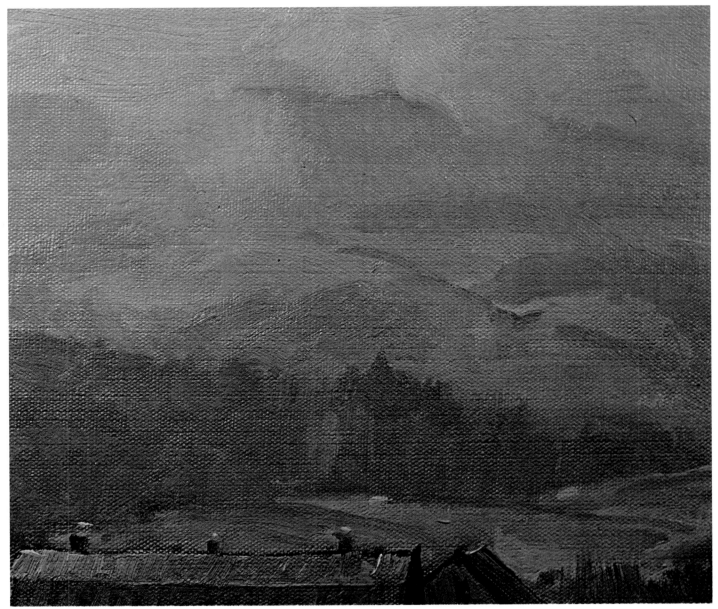

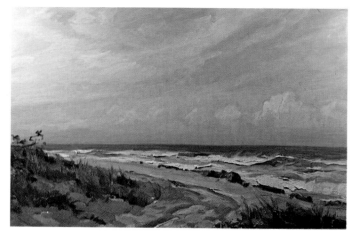

Jensen Beach, Florida, oil on canvas, 30" x 36" (76 x 91 cm.). I was drawn to this site by the way the upward movement of the clouds counterpointed the downward sweep of the beach.

Detail. The tracks in the sand create a strong entrance into the picture. I've varied the paint texture and color to suggest the different sand layers. The darker areas have been untouched for a long time; the lighter, thicker ones were recently turned by a passing truck. The background sand is flat; the rough foreground has a chance to tell. In the distance, a cluster of dark rocks separates sand and water; it acts as a dark accent to the lighter foam. The water itself is dark toward the horizon and becomes lighter and warmer as it nears the shore and mixes with the foam and particles of yellowish sand. The foamy, sunlit parts of the small waves are very heavily painted. The strokes follow the movement of the wave. In the center of the detail, they curve where the wave curves. Near the beach, a squiggly line suggests the front of a small breaker.

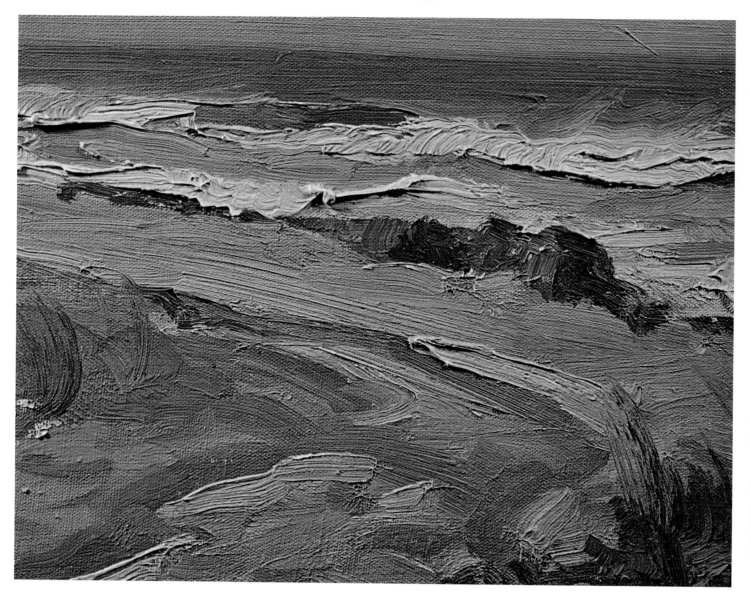

ROADS

During the course of this book I've repeatedly stressed the importance of getting *perspective* into your pictures. The viewer should clearly understand what is in the foreground of your design, what in the middle-distance, and what in the background. Roads are a good example of this point. I always tell students that they create a strong feeling of depth in their pictures when they make their roads very large in the foreground and very small in the distance. Stand in the road before you paint it and look to your right and left—see how *big* the road is! Yet students invariably paint roads that go straight down the middle of their canvas. They look like paths—or like a road seen by a bird flying half a mile overhead. So look where you're standing! Chauncey Ryder, the famous landscape painter, always brought his roads right out of the sides of his canvas. They were immense in the foreground. But they narrowed so rapidly as they moved into the distance that you couldn't help being pulled deep into his compositions. He exaggerated what he saw—and thus better expressed what he felt.

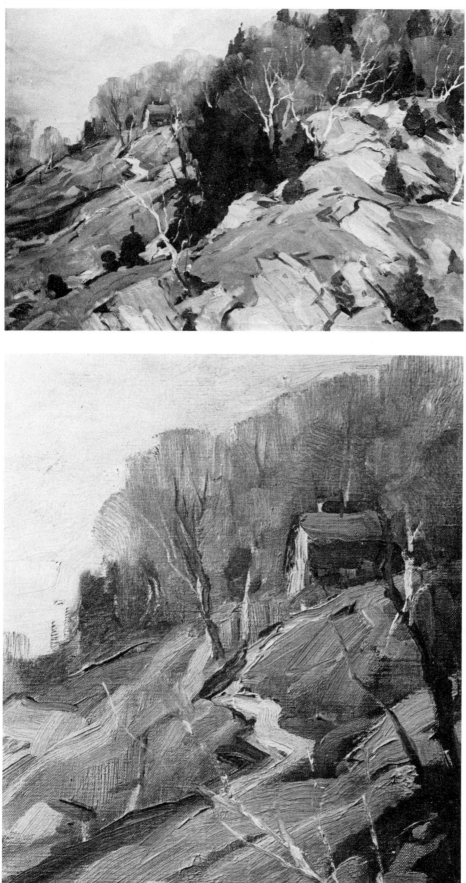

Rocky Pastures, oil on canvas, 30" x 36" (76 x 91 cm.). At this site I was struck by the interesting rock patterns and by the contrast between these light rocks and the dark fir trees.

Detail. This detail shows you the simplest possible use of a stroke. Since the road is far in the distance, I don't need to show detail. As it moves up from the lower left, it's hidden by one of the big convex bulges of the earth. When it turns—at the middle of the detail—we suddenly see more of it. The road is widest near us and quickly narrows as it goes into the distance. Then it suddenly turns and almost disappears from view. The stroke is partly designed to lead the viewer's eye to the small house on the hill. The house adds human interest and gives scale to the scene; you compare the trees and rocks to it and thus get some idea of the size of everything. The lively zig-zag stroke also adds interest to what might otherwise be a vacant area. Look at the complete painting and cover the road with your finger. Do you see how bland that part of the background suddenly becomes?

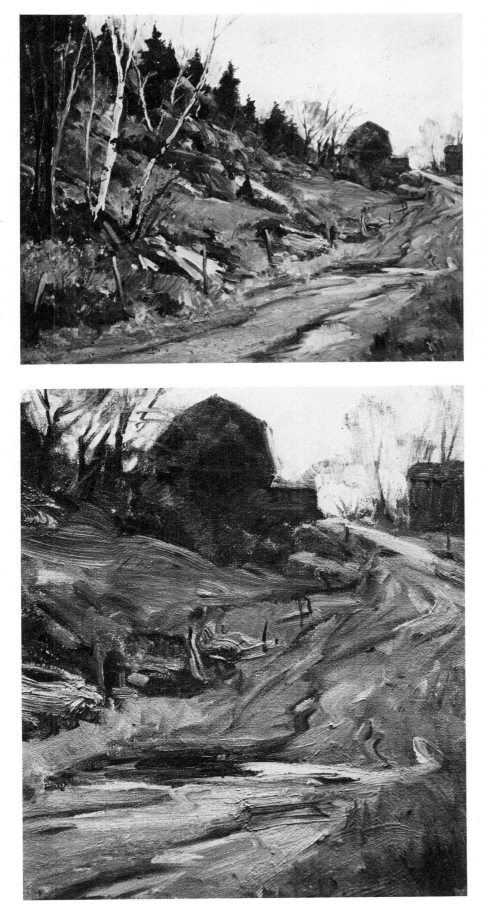

Rainy Day, Vermont, oil on canvas, 30″ x 36″ (76 x 91 cm.). This was painted at the same site as the preceding picture — but looking in the opposite direction. It was a rainy day, and the wet rocks had an interesting sheen to them — they looked very light and blue.

Detail. The road in this picture is large — but I use the same principles as in *Rocky Pastures.* Instead of one stroke following the direction of the road, I use a number of directional strokes. In the immediate foreground the road lies flat, so the strokes (the ruts and erosion marks) are fairly horizontal. When the road climbs the hill, the strokes also move vertically; they become more diagonal as the road levels off. Water collects in areas that are related to the structure of the road. At the top of the hill, for example, the water rests on the flat surface — a quick, light stroke represents the slight glare it catches from the sky. Water runs down the inclined portions of the road, accumulating on the level area in the bottom half of the detail. In the foreground there's another small puddle. It's more rounded than the others; it's near to us and we look *down* on it, thus better seeing its shape.

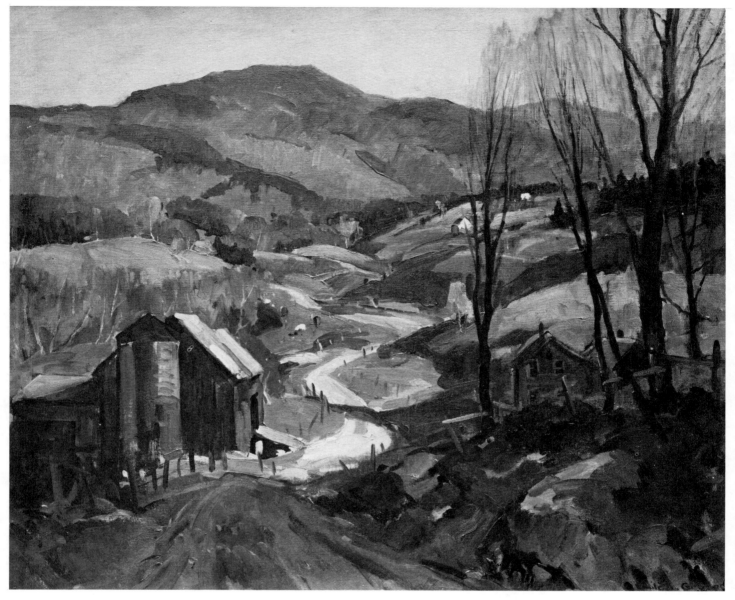

The Farm in the Valley, oil on canvas, 30″ x 36″ (76 x 91 cm.). In the fore-ground, the winding road takes up about half the canvas; it rapidly narrows as it goes into the distance. I've accented the line of the road by placing a series of fence posts near it. The strokes for the posts are big and dark in the foreground and become lighter and smaller as they recede; they finally disappear al-together. I've tried to counteract the dominant left-to-right movement of the road and the hills by introducing the strong up-and-down movement of the tall trees on the right. The silo and farm to the left provide a similar vertical accent. Without these upright strokes, can you see how the picture would lack dramatic contrast? It would be monotonous. One thing about the picture bothers me. I copied the road as it was and didn't notice that it occupies a narrow band in the middle of the canvas. It looks constricted. If I were painting the picture today, I'd redesign the road, giving it a much wider sweep. I'd pull it far to the right and then have it swing strongly to the left. Such energetic strokes would add to the dynamism of the whole picture.

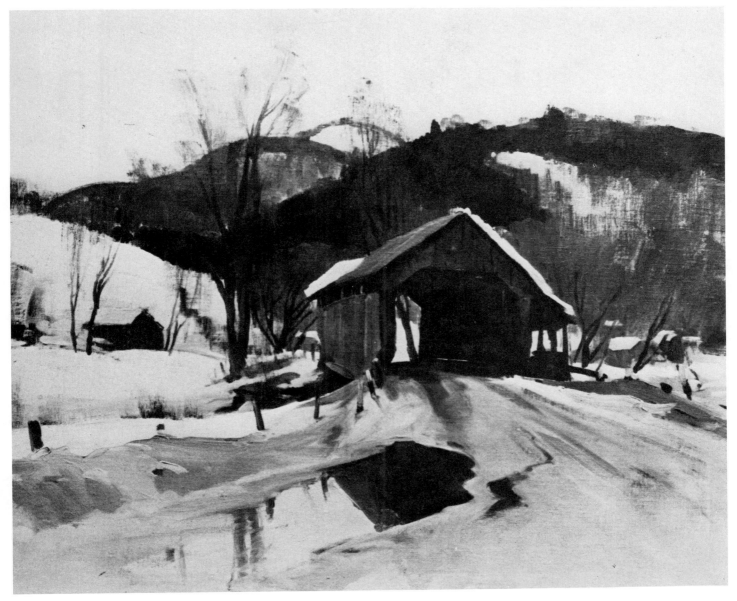

Puddle in the Road, oil on canvas, 30" x 36" (76 x 91 cm.). At this site the road was clearly my subject, so I made it the biggest thing in the picture. It runs out of both the left and right sides of the canvas. The old, packed snow looks dark and muddy. As the road approaches the bridge, you can see the ruts and dark spots in it. In the foreground, however, the snow is painted as a big, flat mass; ruts and other textural details would only detract from the puddle and the bridge. As in *Rocky Pastures* (page 106) the puddle is near us, and we can look down on its curved shape. It's shallow, and there's not much action on its surface. It's painted very flatly. The stroke that makes the thin puddle on the right is very important. It accentuates the wavy edge of the main pool and gives the eye a zig-zag path into the picture. The stroke also tapers as it recedes, further emphasizing the perspective of the road. The quickly brushed-in background trees are again designed to break the horizontal movement of the rest of the picture; notice how the branches—suggested by a few large strokes—cut into the line of the mountains, making them less harsh and obtrusive.

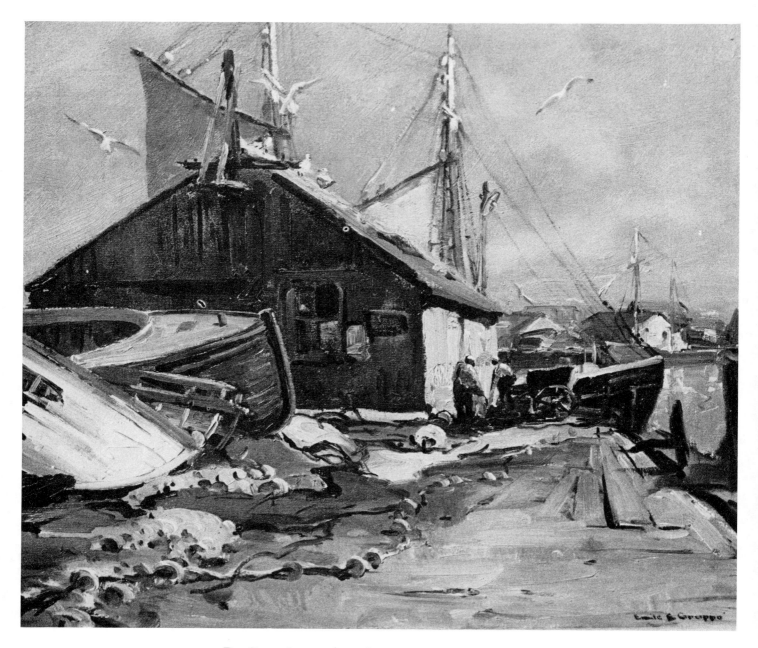

Derelicts, *oil on canvas, 25" x 30" (64 x 76 cm.) collection·Felicia Oil Company. In the right foreground, strokes representing boards lead you into the picture, while to the left, dark swirling strokes also direct the eye inward. Random dots and dashes suggest piles of fishing gear. The shadow side of the main building is made interesting by a series of horizontal and vertical strokes; a dark blob suggests a broken window. The sunlit side of the building is painted as a simple mass; the glare obliterates details. The immediate foreground and sky are both brushed in with big, simple strokes. They give the eye some relief after looking at all the activity in the rest of the picture.*

BUILDINGS

When you paint buildings, think first about their *character*. Remember that they're manmade objects. They're in geometric contrast to their natural surroundings — to the rolling hills and the rounded shapes of the nearby trees. Stress the angular structure of your buildings. If something obscures these characteristic shapes, remove the obstruction — or don't paint the picture. The viewer wants to see how the building is put together; otherwise, he'll only be confused.

When you paint buildings, either paint them small—as an addition to a landscape, where they become part and parcel of their surroundings — or paint them big. You can fill the canvas with them. If you really want to stress their size, run them right out of the canvas. Be careful that you don't divide the canvas *equally* between buildings and landscape, or the viewer won't know what subject you're really painting.

I prefer to paint groups of buildings. When you paint just one building, there's always a danger that it will be too specific. If the viewer isn't familiar with the particular structure, he might not be too interested in your painting. I'm reminded of the commissions I used to get to paint a person's home. The picture was of great interest to the homeowner—but to no one else.

When you paint groups of buildings, you have a chance to design your material. You can use the interesting shapes made by the roofs or exploit the shadows that play over the mass. The crisp angularity of a cluster of roofs also gives you a great opportunity to counterpoint one line against another. I've used some counterpoint in *Derelicts* (opposite page). The roof slants down to the right; the sail slants to the left. When the roof slants to the left, the sail slants to the right. One line accents the other, and the eye finds the contrast stimulating. Imagine how boring the picture would be if the lines of the sails were parallel to those of the roof!

When you paint houses, paint what you *see*. For example, buildings in the background are usually seen as a texture rather than as a group of distinct shapes—they're just dots and dashes that the eye, looking at the scene, interprets to be individual houses. If you try meticulously to copy each distant building, your background will no longer be a background—it will be a collection of houses. Also try to get a sense of the history of your buildings. Remember that they weren't built yesterday. See where they sag, where a new board replaces an older one, where the roof and the walls have been weathered and battered.

Keep scale in mind, too. Your largest buildings should be in the foreground, with the smaller ones in the distance. At a site, there may be a one-story structure in the foreground and a three-story one in the distance. They look the same size. But don't paint them that way! You'd confuse the viewer. He expects buildings to get smaller as they go back into the distance. If you don't give him the expected clues, he won't understand the spatial relationships in your picture.

Shadows, oil on canvas, 25" x 30" (64 x 76 cm.). Here I was struck by the interesting shape that the different-sized farm buildings made as they clustered together on the hillside.

Detail. I've directed your eye toward the central barn by making it the biggest and most detailed building. The building to the far right, on the other hand, is formed by a few simple light and dark masses. Two dots suggest windows. The principal structure is composed of vertical strokes. They create an upward movement that makes you *feel* as if you're looking up at the building. (The tall vertical trees reinforce this impression.) At the same time the thin verticals are contrasted to the hillside's rounder, broader strokes; one movement accents the other. To the left a covered area is held up by light and dark poles—with light dots in the dark shadow. I don't know precisely what these dots are—but they break up a flat area and make it more exciting to look at. The shadow side of the main building merges with the suggestion of a broken fence; the fence strokes add interest to the dark silhouette.

BUILDINGS IN FAR DISTANCE

Dairy Country, oil on canvas, 25" x 30" (64 x 76 cm.). In this picture I liked the way the clearings worked their way up the hill. The "made-land" is what makes Vermont so interesting to paint; it gives the mountains a design that you don't find in New Hampshire or Maine.

Detail. The distant building is merely a dark spot used to break up what might otherwise be an unusually large and uninteresting area of white snow. It's just a series of simple, horizontal strokes. A small dark stroke connects and accents the lighter buildings, suggesting the direction of the sunlight. A quickly brushed halftone behind the houses suggests a tree, perhaps; but it also accents the snow-covered roof of the house and connects the buildings to the evergreen mass in the background. The house isn't isolated—so it won't attract too much attention to itself. Other dark strokes are used for the same purpose. Beneath and to the left of the buildings a few strokes connect the house and the dark foreground evergreens. To the right of the houses a long, thin stroke suggests a cast shadow and again links the buildings to the area of shadow on the far right. The house is thus firmly tied to its surroundings; it doesn't disrupt the design.

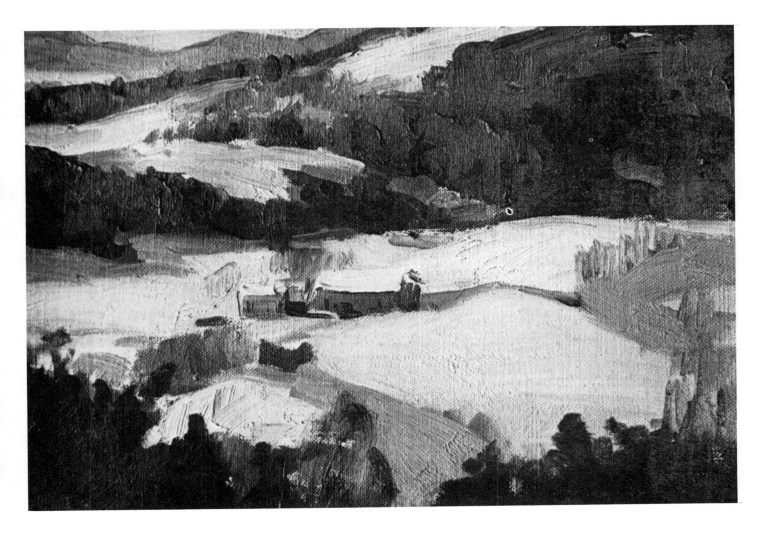

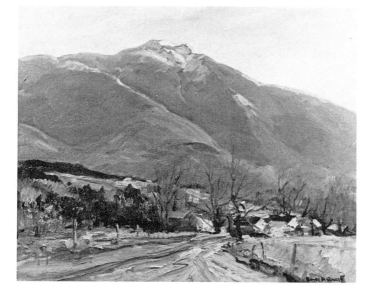

Mount Mansfield, oil on canvas, 30″ x 36″ (76 x 91 cm.). This picture was painted for the sake of the mountain—everything is sacrificed to that one goal.

Detail. To accentuate the mountain the houses are painted very simply. There's one dark stroke for the roof, a halftone for the side in shadow, and a highlight for the sunlit side. I put the buildings down just as I saw them: bing, bing, bing! The highlights have the heaviest impasto; they catch the light and are easy to see. The background is painted much more thinly; you can see the texture of the canvas. In front of the houses, on the other hand, I built up a heavy foreground texture. Long, horizontal strokes represent the ground, and wavy strokes suggest grass areas closer to you. Similarly, the tree to the left of the houses is nearer to you; I painted it more thickly. The trees to the right are further back—and so are more thinly painted. The large masses of the complete painting are similarly handled. The distant mountain is painted flatly; but the foreground is thick with paint. The textures tell you that one area is close, the other far away.

Panorama of Gloucester, oil on canvas, 16″ x 24″ (41 x 61 cm.). This is a sketch for a mural. It's supposed to be decorative—as a result the paint texture is flatter than that of an easel picture, and the interest is spread more generally over the canvas.

Detail. In the detail you can see how I've again suggested houses by reducing them to their most elementary characteristics. Light strokes indicate places where the light hits the buildings. Dark strokes suggest shadows. These strokes also add shape to the houses. They're sharp and geometric, and so give corners, tops, and sides to the buildings. You sense that you're looking at square, man-made objects. The fact that the darks are to the right of the buildings suggests that the sun is to the left. Notice that these dark strokes are joined together. They not only accent interesting patterns of light, but also form unified and interesting patterns of their own. None of these buildings has windows. In the complete painting the only dark windows occur toward the center of the composition. That's where a few dots count; they help attract the eye to the hill and the buildings beyond. Windows at the side of the design would be far too distracting.

COTTAGE

Rose Garden, oil on canvas, 25″ x 30″ (64 x 76 cm.). This is clearly a picture of a house. I made the house big so it dominates the canvas, just as I made the houses small in *Mount Mansfield* so they'd emphasize the size of the mountain.

Detail. The strokes of the dormer window exactly parallel the direction of the wooden boards: vertical strokes, a horizontal stroke for the lintel, diagonal strokes for the boards that hold up the roof. Why have I blurred the panes of glass? Robert Henri used to say that when you do a portrait, you should feature one eye or the other—not both. Here I've decided to let the more precisely painted window on the left of the complete painting be the main one. (The same principle is at work on the ground floor: the left window is completely visible; the right one is obscured by shrubbery.) When painting a shingled roof, get the mass down first, noting any interesting changes of color that have been caused by weathering. Then just place a few horizontal and vertical lines to suggest the character of the material. There are fewer shingle markings on the roof as you move toward the source of light; the side nearest the sun catches a glare that obliterates individual shingles.

Reflections, oil on canvas, 20″ x 24″ (51 x 61 cm.). Here the main subject is the boats and their reflections. The houses serve as a framing device, keeping your eye in the picture.

Detail. The strokes representing the individual boards of the house all angle in perspective toward the center of the picture. They give the picture depth and also direct the eye of the viewer to the boats. The individual strokes again correspond to the nature of the material. Thick strokes indicate the boards that frame the window, while thinner strokes suggest the individual panes of glass. Thick strokes indicate the boards of the wall — thinner strokes suggest shadows cast by the individual clapboards. Toward the top of the building, the overhanging roof protects the painted boards from rain and the bleaching action of the sun; the strokes that make up that area are all relatively dark. Near the ground the boards have weathered. People lean fishing gear against the wall, scraping off the paint. Here and there a new board replaces a rotten one. That's part of the history of the building — and gives us a great chance to vary our colors, values, and textures.

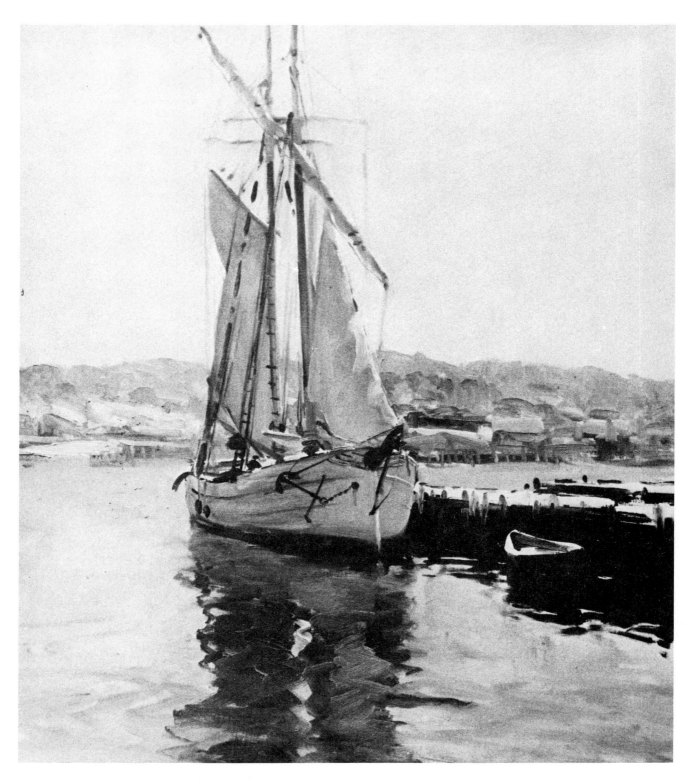

Sunlit Sails, *oil on canvas, 18" x 20" (46 x 51 cm.). This is a study of a boat—I didn't worry about making it into a "picture." If I were composing it, I'd pull a dock across the front (so you could see where you're standing) and enlarge the background to the left of the sail. A bigger hill would balance the dark pier to the right. The sun is in front of us, so the boat becomes a silhouette. It's flatly painted. Remember that objects lit from the back are always simple in texture and shape. You can't see the modeling within the mass. By keeping the sails simple, I'm able to play up their sunlit edges. Since I want you to feel the size of the boat, I painted the pilings along the wharf with small, thin strokes. The little foreground dory also helps give scale to the picture.*

118

BOATS

It takes time to understand how boats actually look. When I began painting them, my proportions were never right. I talked to fishermen in order to find out how boats worked. And I made countless studies of individual schooners and draggers. Eventually, I began to see where the cabin goes and where the masts belong. I saw the ropes that keep the mast from falling forward, backward, and to the sides. And I began to sense how the shape of the boat was related to its particular job. You start by mechanically copying the facts — then you begin to *feel* the character of the boat: its lightness or heaviness, its strength or fragility. Once I knew the subject, I could begin to take liberties.

As a good example of how to think about boats, look at a sailboat on the horizon. At first, students draw the billowing sail and then work hard to paint the small boat beneath it. Eventually they begin to stress the important part: the sail. I tell them that a sailboat is like a butterfly: you see the wings — and never notice the little worm they're attached to.

Be decisive when you draw boats. Either pull the mast right out of the picture — or keep it clearly within the composition. Don't have it just kiss the top of the frame, so that it looks as if it's dangling from it. I usually keep my masts inside the design; that way the viewer sees the whole boat and better understands how it's constructed. If I do pull one or two out, I keep a few others in. The ones inside the picture explain those beyond the frame. Similarly, when I pull all the masts out, I try to reflect the full mast in the water. The reflections then tell the viewer what's happening outside the canvas.

In order to scale the boats properly, I place the masts first; the design they make against the sky is usually the most important part of the picture anyway. Then I draw the hulls to fit them. I like to make the masts tall — students rarely give them enough play. Students also tend to make their ships too big. Instead of a composition, they end up with a portrait of a boat.

Always keep scale in mind as you work. If you want the boat to look big, keep everything around it small — people, buildings, pilings. A small dory next to a large ship scales the whole design.

Don't paint the same picture of the same boat over and over again. Paint only what interests you at a particular moment. Do a panoramic view of the harbor one day; the boats will be props. On another day make a close study of a ship, playing with the rusty, battered hull and the gear that litters the deck. On another day use the foreground boats as a decorative screen. But above all, learn to *look* for the character of your material. I used to take groups of students down to the wharves. One of the boats would pull away halfway through the lesson — but none of the students would notice! They were too busy moving paint around on the canvas. They had stopped looking — and studying.

BOATS IN FAR DISTANCE

Lobsterman, oil on canvas, 25" x 30" (64 x 76 cm.). This is a picture of junk. Look at the lobster pots, for example: one moves to the right, one to the left; one is straight and another is at an angle. Nature created the design—all I had to do was paint it.

Detail. The foreground is my subject. As a result, I keep the background simple. I have to include some boats so that it looks like a harbor, but notice that the background boat is painted as part of the harbor wall. It's hooked on to something and doesn't stand out. A few light strokes suggest the sunlit sides; darker strokes represent shadows. The dark background (seaweed on the wall) accents the boat's angular shape. If I added windows to the boat, I'd soon lose the spirit of the mass—and the added detail would detract attention from the foreground. The viewer wouldn't know where I wanted him to look. Notice how one dark stroke — a dory — cuts into the reflection of the lobster boat and gives it a more interesting shape.

Boats at Anchor, oil on canvas, 30" x 25" (76 x 64 cm.). I liked the way the foreground boats all came together in a large mass. The boat at an angle on the lower left makes the picture: it counterpoints all the other boats. Cover it with your finger and see how everything suddenly seems to be sliding out the picture's lower right corner.

Detail. There are many large and carefully drawn shapes in the foreground of the picture, so the background shouldn't be as interesting. I just wanted to convey the feeling of small boats in the distance — spots, a light-and-dark design, a texture. The background boats are all composed of quick, horizontal strokes. To explain the strokes, I accent the bow of the boat on the left and the bow of the white boat on the right. These two characteristic shapes tell the story. The far distance is simple and dark; the boats stand out clearly. A few vertical strokes (masts) counterpoint the boats' horizontal movement. The rigging on these masts is very quickly done — I took the end of my brush and scraped some lines into the wet paint! The dark silhouette of the man brings out the whiteness of the distant sailboat.

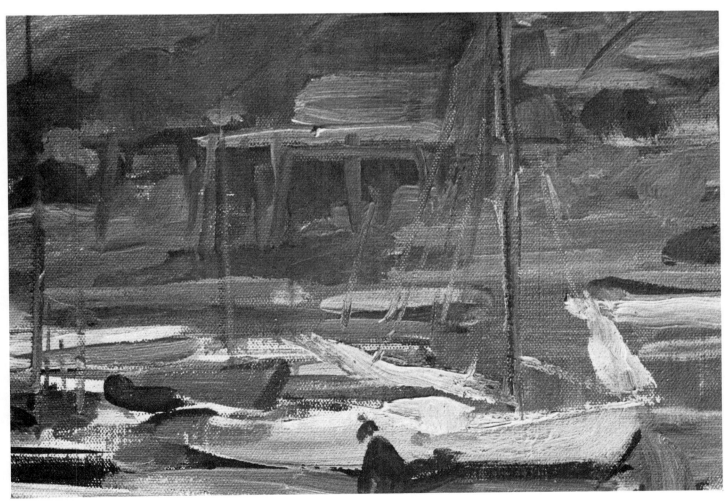

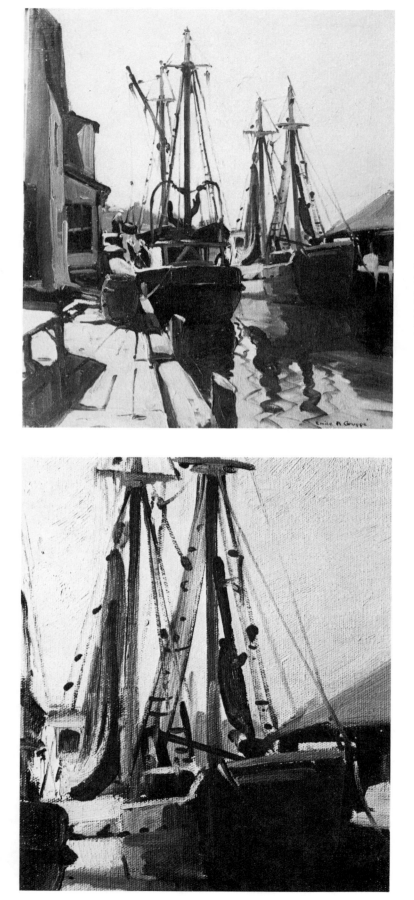

Boats at Dock, oil on canvas, 18" x 20" (46 x 51 cm.). The boats are lit from the side, and the buildings and mast form an interesting silhouette.

Detail. Each mast has two rope ladders running from the side of the boat to the crossbar. But I painted only one in detail, the one nearest to us on the forward mast. The others are just a few lines with dark slashes to indicate an occasional rung. When you show a thing once in a picture, don't feel you have to show it again and again. The pulleys are dark dots; they add visual interest to the area around the mast. A rope in the upper half of the detail goes from the back mast to the forward one and ends in a pulley. I didn't complete the line, tying it to the mast—but who cares? If I carefully drew every rope and pulley, you'd feel my labor; you'd tense up and tire as you looked at the picture. I want you to *feel* the rigging, without actually seeing it.

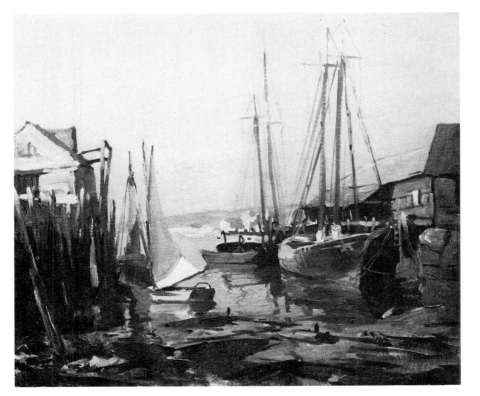

The Sadie Noonan and the Wentworth, oil on canvas, 25" x 30" (64 x 76 cm.). Here I liked the way the schooners nestled against the pier. The mud also formed an interesting pattern as it angled toward the large boats.

Detail. The simply painted corner mass balances the activity of the right side of the picture. A light stroke breaks the mass of pilings and represents the background water. Notice how refraction limits the amount of light coming through the opening and makes the area look darker than the water in the open harbor. The sail is very flatly painted. You see it—but you're not distracted by it. The edge of the sail droops in a concave line, and the shadow on the sail counterpoints and accents this movement; you feel that the sail is hanging. Probably the most important stroke in the picture is the diagonal line at the extreme bottom left of the detail. It adds interest to the background pilings by breaking their dominant up-and-down movement. And it strongly counterpoints the line of the Sadie Noonan's masts. Look at the complete picture and cover this piling with your finger. If this were gone, the note of contrast that gives life to the whole composition would be lost.

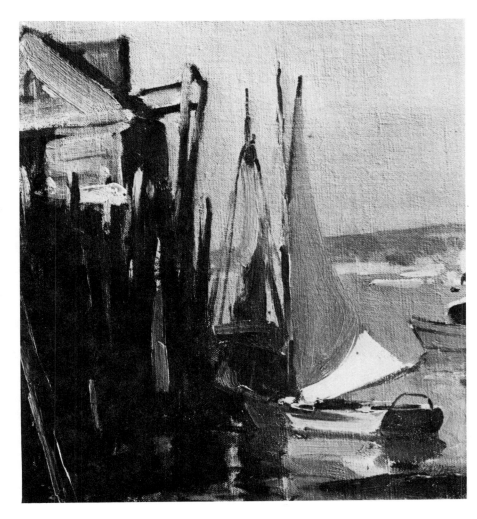

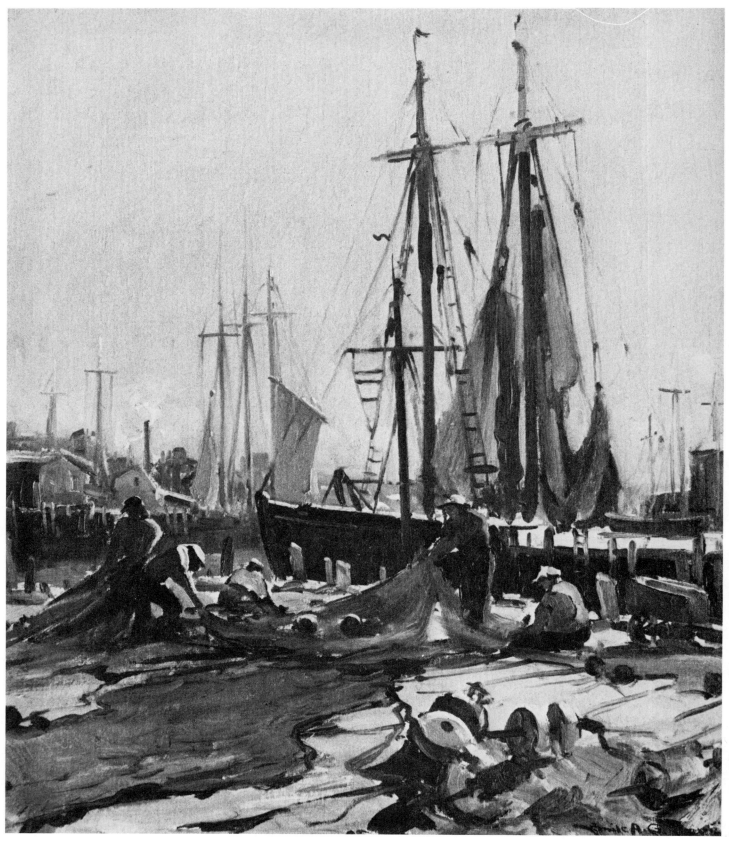

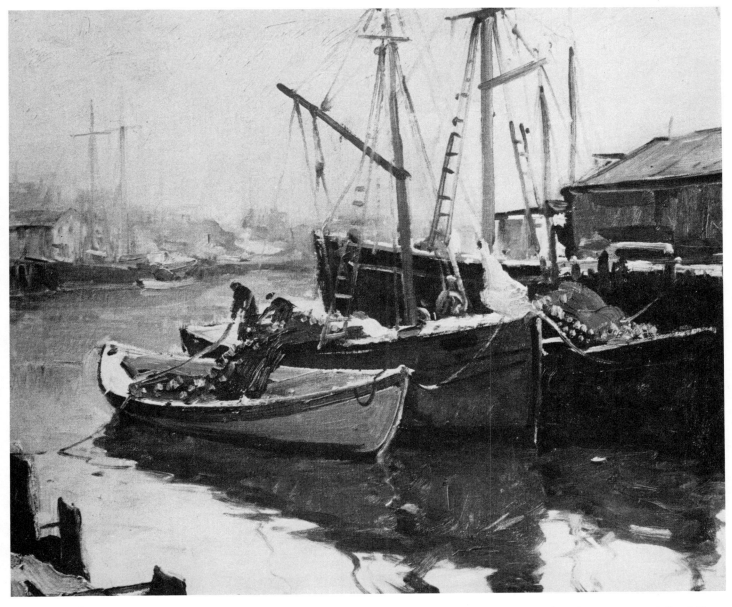

Mending the Nets (left), oil on canvas, 25″ x 30″ (64 x 76 cm.), collection of the Sawyer Free Library, Gloucester, Massachusetts. The flatly painted foreground net leads you into the picture and acts as a relief from the active brushwork that describes the men, ropes, and the round cork floats. In the lower right corner the nets and corks are detailed and textured — they look close to you and contrast effectively with the smaller corks in the distance. To the left of the wheelbarrow, one big stroke represents a nearby piling. Directly above it, the background pilings are represented by eight strokes. You sense how far away the area is. The flat strokes of the net give way to diagonal strokes as the net is lifted by the man in the center of the picture. These strokes define the movement of the whole picture. Notice how they're picked up by the more vertical strokes of the hanging background nets. As in previous pictures, I wanted to accentuate this movement by counterpointing it.

Unloading the Nets (above), oil on canvas, 25″ x 30″ (64 x 76 cm.). In this picture the movement is again upward. The net, as it's pulled out of the seine boat, is painted with heavy, diagonal strokes. This movement is repeated and accentuated on the right by the rope that ties the seine boat to the boat in back of it. It's repeated on the left by the long stroke running from the upright worker, over the seine boat, and into the water. The boom in the upper center of the picture counterpoints the movement of the nets and ropes. In the far distance a few vertical strokes suggest the masts of a schooner; they catch the viewer's eye and keep it from wandering out of the left side of the picture. Dark strokes on the right represent the roof line of the wharf building. They slant downward slightly into the picture and direct you toward the main boats. If these strokes had been straight, the picture would lose some of its depth. The principle boats are lit from the back and are very simple in texture.

Toward Rocky Neck (above), oil on canvas, 25" x 30" (64 x 76 cm.). The strokes of the heavily textured road and the perspective of the white house in the foreground on the right all point toward the left. The eye is arrested by the darks of the partially shadowed house on the left; and its perspective lines point the viewer across the cove to the distant white sail. A few quick strokes represent anchored boats, while the two white vessels act as stepping stones, leading you from the foreground house to the sail. The most detailed background building is to the left of the sailboat. You can see the individual strokes of the pilings and the dark dots for windows (the only dark windows in the background). If this building were to the right of the sunlit sail, your eye would go to it and then shoot out the right side of the picture. As it is, however, the eye moves from the sail to the *left*, follows the long float, and then goes up the hill and into the hazy distance.

The Old-Timer (right), oil on canvas, 30" x 25" (76 x 64 cm.). Here I was struck by the sails and their big reflections. The foremost sail on the far right is the tautest and also the most simply painted. Along its front edge I've shown how the sail is tied to the overhead ropes—you can see a thin dark stroke with dots at the intersections. On the second sail I played down the ropes and instead studied the texture of the hanging sail. You can see the concave line of the bottom of the sail — and the evenly spaced halyards (ropes) that are used when the sail is partially furled. The third and final sail is the darkest—it's shadowed by both forward sails—and tells the most about how sails hang. Dark strokes fan out at the base of the sail indicating the tensions in the convex, drooping mass. The men and boats in the foreground give scale to the design. That dory is so small that you immediately appreciate the size of the old-timer.

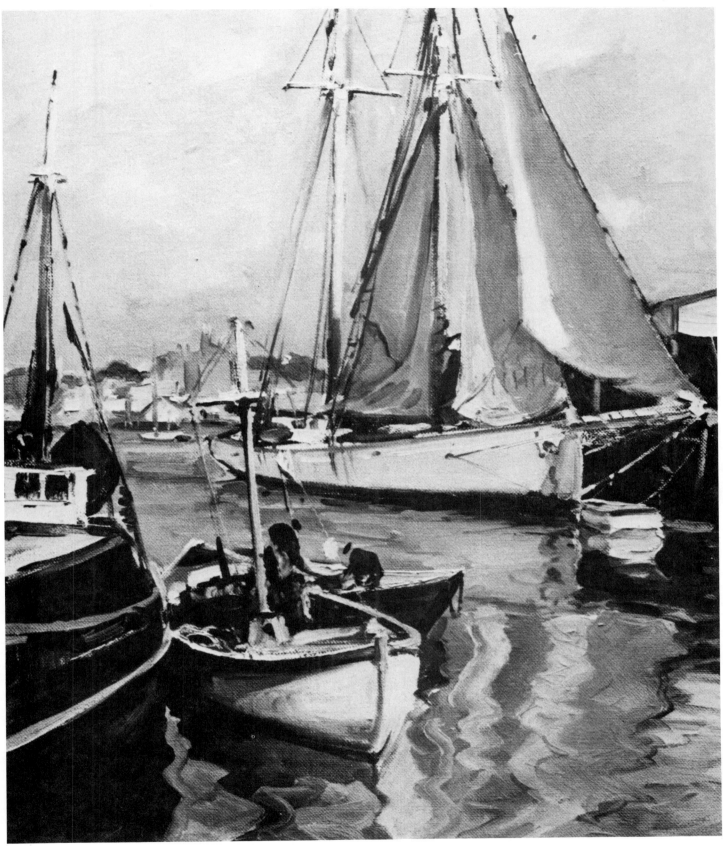

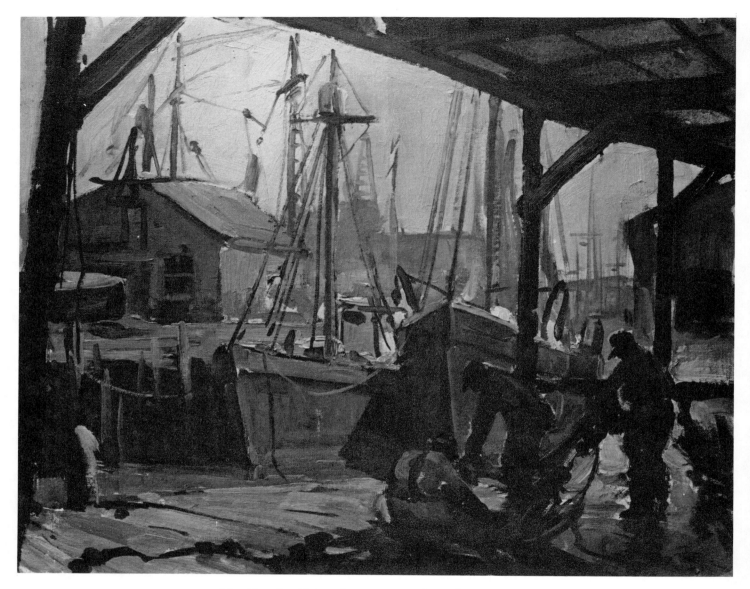

Mending the Nets, *oil on canvas, 20" x 24" (51 x 61 cm.). The figures in this picture are simply painted. A few big strokes form the pants, shirts, and heads—while thin strokes indicate suspenders. Net, workmen, and architecture all come together in one dark unit. The seated figure merges with the shadowed top of the wharf. The middle figure is connected to the post directly behind him. The figure to the far right is similarly tied to the wooden roof supports. Squint at the painting, and you'll see how men and building form an interconnected shape. You see them; then your eye moves on to the sunlit boats in the distance. These boats are my real subject; the foreground simply frames them.*

FIGURES

Before you can paint a figure you need to know how to draw one. I was lucky: I had two fine instructors in figure drawing. And their ideas differed greatly. One was a great anatomist; he'd draw figures upside down, starting with the foot. Then he'd turn the paper right side up and show us a figure in perfect proportions! He made us *see* the figure; we learned how it moved and worked, where the leverage points were, what it could and could not do.

My other instructor had a more artistic, intuitive approach. He made us draw a dozen lines—then choose the one we liked best. We felt our way into a figure, searching for the qualities that most appealed to us.

Probably the most grueling part of this teaching — and the one of most use to the painter — were the classes in which the model didn't pose at all. He slowly walked across the floor, bent over, climbed a stand, and then walked back behind a screen. As he moved, we picked the pose we liked best and drew it from memory. The instructor said the exercise showed "what you have in your brains rather than in your eyes."

The exercise taught us how to catch momentary movements and record them quickly. If you paint a group of workmen outdoors, for example, they're not going to pose. You have to study them, searching for the twist of the body and bend in the back that fits what you want to say. Your hand has to translate what the eye sees, quickly, and with just a few shorthand strokes.

Figures are a great asset to a painting; the viewer's eye goes right to them. So have them doing things near your center of interest—looking in a window, raking leaves, pulling a net, hauling a sail, filling a pail with sand. Also remember to scale them properly. Make them look as if they can go in the doors of nearby buildings. Small figures in a painting make everything else look large; large figures make the surroundings seem small. Winslow Homer, for example, often put small figures in the foreground of his marines; by contrast his rocks and waves seem that much more massive and impressive.

The proportions of your figures play an important part in how the viewer interprets them. A figure seven heads high looks normal and dignified; one nine heads high looks like a giant. If you make the heads of workmen small, you emphasize the strength of their bodies; when the body is only five heads high, we know we're looking at a child. This progression is particularly evident in the painting *My Daughter* (page 131). The proportions of the figures tell the story.

I like to convey the idea of a figure without carefully drawing it. If the whole picture were meticulously finished, then a carefully drawn figure would be appropriate. But when you work impressionistically, as I do, the figures should be painted with a consistency of approach. Then the viewer doesn't feel that you've imported your figures from another painting.

Drying the Seine Net, oil on canvas, 25″ x 30″ (64 x 76 cm.). Here the site had an enclosed feeling. There's little depth to the picture, everything occurs on the same plane.

Detail. The figures are all bending in one direction or another. The simplest strokes—small dots on the heads and curved highlights on the shoulders—are enough to define the character of the figures. These highlights gain in effect because the figures are silhouetted against a simple, dark background. The line of the net holds the figures together. Notice that the men are all clustered around one boat. They usually get together to help one another. But even if they didn't, you'd want to concentrate them near the central point in your composition. If you had men all over the place, the viewer would feel you were throwing a masquerade party. Since the seine boat is filled with dots and dashes (men and nets), the boat itself is more broadly painted. It's a simple silhouette in shadow and doesn't compete with the figures.

My Daughter, oil on canvas, 18″ x 20″ (46 x 51 cm.). The foreground figure is nearest to us; it has the most detail and texture. Notice, for example, the heavily painted blouse. Her hair is worked into the wet background, blurring it at places and making it look as if it were blowing in the wind. By losing parts of your figures, you make them look less like cutouts and more like bodies surrounded by atmosphere. The dark, seated figure to the left is farther back—and so more thinly painted. She bends to the right, directing your eye into the picture. The man standing in the light beach robe is even more simply painted, and the figures in the water are just dots. Since the sand and water are painted with broad strokes, they don't detract from the figures. Notice that the sand is darkest near the water—where it's wet. Both the sky and the sand are relatively light—but not so light that they compete with the sunlit clothing of the bathers.

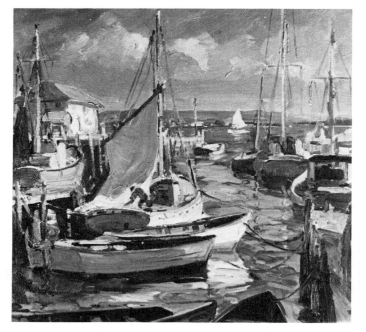

Crowded Harbor, oil on canvas, 25" x 30" (64 x 76 cm.). This was an unusually active day in the harbor, with boats everywhere. Fortunately the sun pulled the design together. To the left the main area is mostly in sunlight. To the right there's a smaller, subsidiary area, mainly in shadow. The water area leads you into the distance.

Detail. The figure is bending and working. The legs, arms, and torso are one mass; a dot suggests the head. Since the figure is against a brightly lit sail, your eye goes right to it. It gives you the picture's scale. It tells you how big the boats are and how far you are from them. You sense how things would be if *you* were walking along the wharf. The strokes around the man follow the shapes of the objects they represent: the curve of the boat, the upright boards of the cabin, the various curved, bulging movements of the hanging sail. Notice that the man bends to the left while the sail swoops up to the right. This counterpoint accentuates the sail's swinging line.

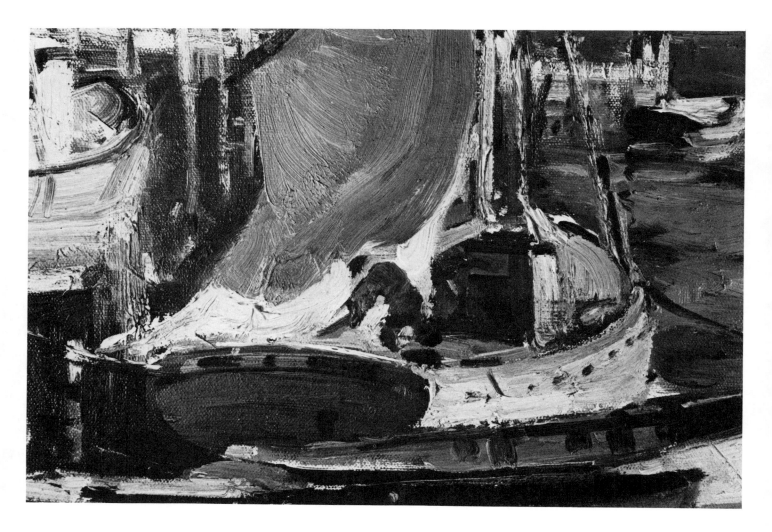

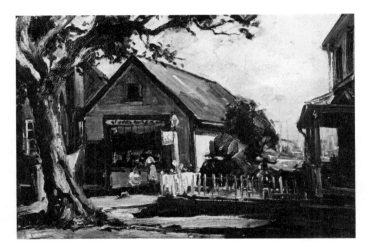

The Little Art Shop, oil on canvas, 20″ x 30″ (51 x 76 cm.). I was attracted to this site by the reflected light in the shadow side of the building and by the contrast between the shop's red roof and the surrounding dark green foliage.

Detail. I look for the essentials: a long, vertical stroke for the mother's dress, a curved stroke for her shoulders, a dot for her hat, a few straight strokes for the legs and arm. The daughter wears a more playful, childish outfit—so the stroke is also playful. It moves in time to the girl's frilly dress. A couple of strokes suggest ribbons in her hair. Since the figures are worked directly into the previously painted texture of the building, it's important that I get them right—the *first* time. If I start to correct, I lose the crispness of the background strokes. Rather than putter, it would be better to repaint the building and start again. In order to get the hanging cord of a pince-nez just right, John Singer Sargent is said to have repainted a shirt more than a dozen times!

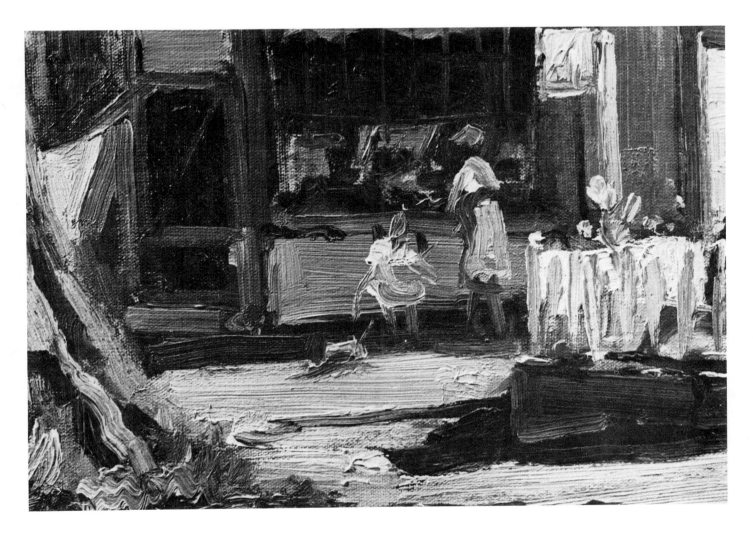

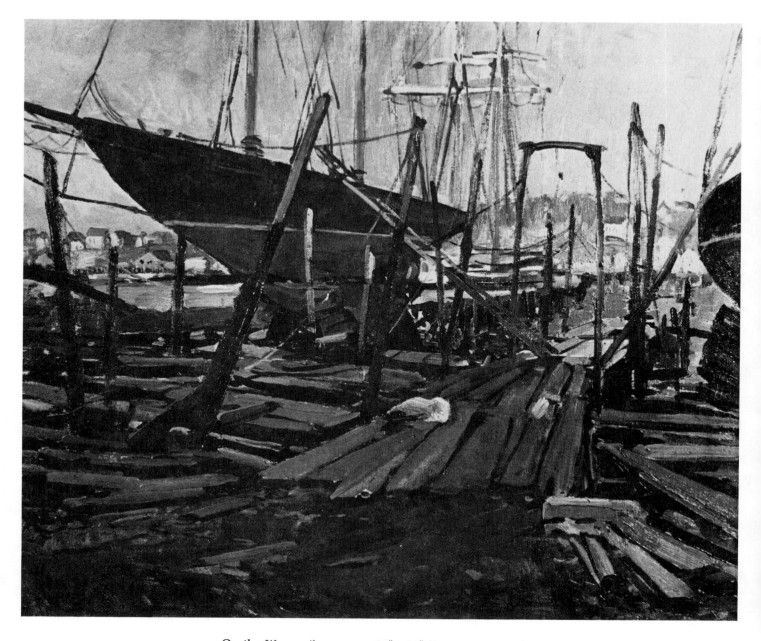

On the Ways, *oil on canvas, 25" x 30" (64 x 76 cm.). Here I was interested in the planks and the apparatus that holds up the boat. You can see how the crisp, angular strokes set the theme for the whole picture. The boards to the left slant in one direction, while the boards in the center slant in a contrary direction. These movements are further counterpointed by the vertical masts and tall wooden cradle supports. Diagonal ladders add another contrasting line to the composition. Although there's a lot of dynamic repetition, contrast, and opposition in the picture, the active foreground is unified by the all-encompassing late afternoon shadows.*

ORCHESTRATION

We've looked at a variety of different paintings and details; now we can end our study by looking more closely at a few selected pictures. These compositions summarize much of what I've been talking about throughout this book. In discussing them I'll emphasize the orchestration of various kinds of brushstrokes into one complete painting. Also these paintings allow me to emphasize once again the relationship between brushstrokes, the character of the day, and the nature of the scene or object being painted. This relationship is central to my point of view, and I feel it bears repeating—and repeating.

Some of the following pictures are painted thickly and some thinly; some are textured and some are not. Remember: the actual thickness of your paint has little to do with the quality of your work. Slopping paint on an inch thick isn't going to make you into a painter. What counts isn't how *much* paint you put on—but *where* you put it.

Make an effort to understand the subject—and your reaction to it. What specifically attracts you to the site? Why do you want to paint it? If you always look at the world through wide-open eyes, you end up seeing everything. You don't discriminate. Learn how to glance at a subject—how to catch and hold onto your first emotional reaction to the scene. In the painting *The Inner Harbor* (page 136), for example, I was struck by the way a blast of afternoon light turned the landscape into a series of simple light and dark shapes—shapes broken by the abrupt, staccato rhythm of fenceposts and the edges of mechanically quarried stone. If I'd stared long enough at the subject, I'd eventually have seen the shadows on the clapboards and the little indentations in the rocks that make up the pier. But the shadows of the clapboards weren't what struck me when I looked down the lane. Another person might be impressed by that aspect of the scene. But I saw and felt the relation of a few large shapes. I liked the big pattern—and wanted to get it down on canvas.

On the other hand, in the painting *Sycamore* (page 142), I was attracted to the individual textures of the materials. The lower trunk of the sycamore was rough and dark. Higher up the branches had begun their fall peeling. That created an entirely different texture. This contrast has always fascinated me—one reason I usually try to paint sycamores toward the end of the year. The rest of the time they have a sameness that I don't find as exciting. Add the crisp, broken pattern of the fall leaves against the sky, and you have a subject that almost paints itself. But first you have to know how to *look.* You have to have a point of view. I've tried to help you with the first—I can suggest things to look for. But—fortunately—I can't give you a viewpoint. That's up to you!

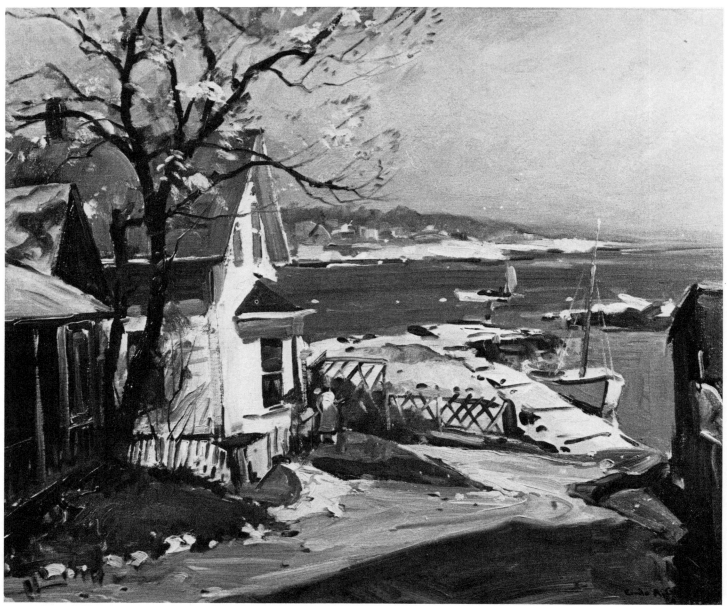

The Inner Harbor, oil on canvas, 25″ x 30″ (64 x 76 cm.). This was painted on a very bright day. You can see the long shadow that runs across the foreground —and the crispness of the edges of objects and the depth of the dark accents. The clear light on the house and pier obliterates details. They both catch a glare from the sun.

Detail. The light on the house is so strong that you can't see the shadows cast by the individual clapboards. Instead, everything falls into large areas of light and dark. The side of the house, for example, is a light mass. The grass is a darker mass. To add interest to these masses, I use a calligraphic stroke—a series of rapid dark lines that are like handwriting marks. The fence in front of the house, for example, is a series of quick upright lines. A few dark squiggles in the light walk suggest individual flagstones.

Detail (below). The stone pier also catches a glare; you can't see the irregularities of the rock. A few quick, dark strokes show you the edges of the slabs—dots add interest. The fence is drawn with a series of criss-crossing strokes. In all cases these calligraphic strokes are placed and left alone—the sharpness of line matches the clarity of the day.

137

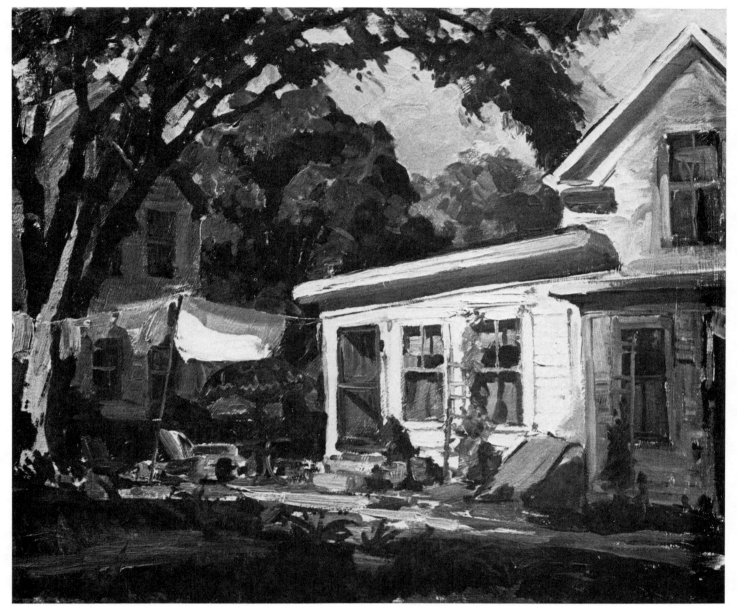

The Back Yard, oil on canvas, 25″ x 30″ (64 x 76 cm.). This represents another bright day. But here the sun, rather than obliterating the materials, begins to bring out their individual character. There's a great variety of texture in the plants, architecture, and trees.

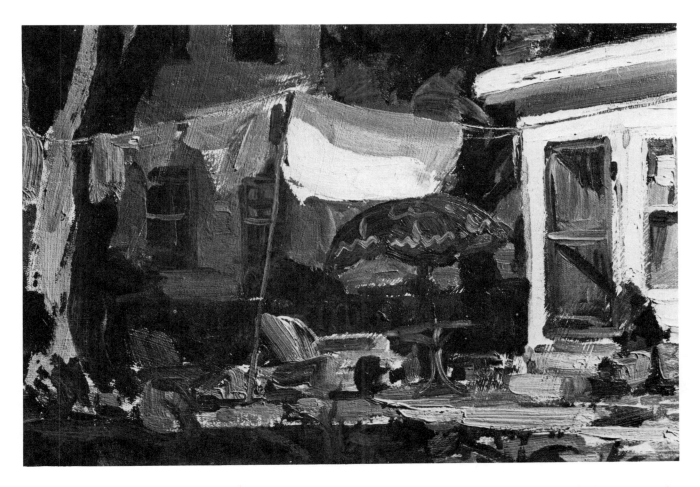

Detail (above). The strong light brings out the essential lines of the materials. The lawn furniture, for example, is composed of a few sharp, geometric strokes. You see two intersecting strokes and recognize a chair—you don't have to see arms, legs, and the individual boards that make it up. The umbrella is a big, convex shape; it's painted with rounded, bulging strokes. A design is squiggled on it—enough to suggest a decoration without being too literal. Beneath the umbrella a table is described by one horizontal stroke (the top) and two concave lines (the legs). The area is a texture. It's how the spot looks when you glance at it and don't consciously focus on the details.

Detail. Under the raking light the clapboards cast thin shadows. I've drawn a few—but not every one. Notice how the stroke is related to the material: each clapboard is a single, horizontal stroke. Horizontal strokes also suggest the window shades, lintel, and sill. Vertical strokes form the sides of the windows. The shades cast dark shadows that bring the lines of the window sash into sharp relief.

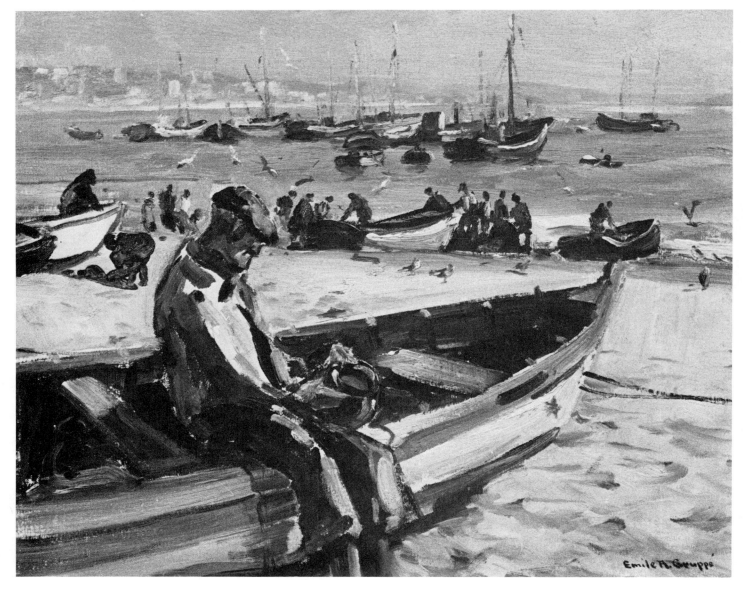

Cascais, oil on canvas, 16″ x 20″ (41 x 51 cm.). Strong sunlight hits the foreground and background figures, breaking them into areas of clearly defined light and shade. Sharp, brisk strokes correspond to the sharpness of the day.

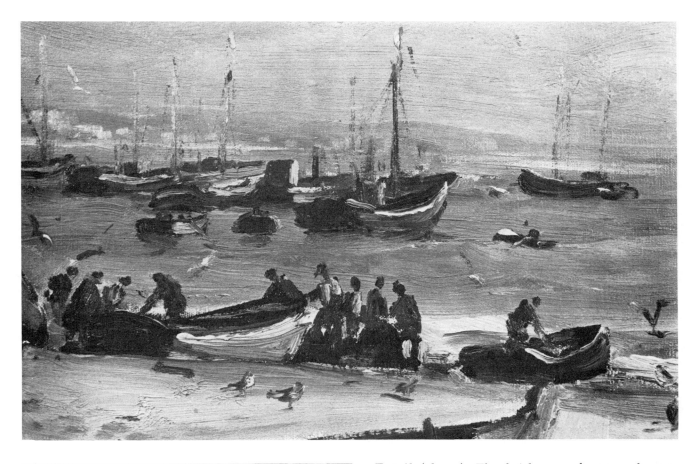

Detail (above). The briskness of approach continues in my handling of the background figures and boats. Men are upright slashes with dots for heads. Notice how I paint a figure as a dark unit — then break some of the background water through it to suggest an arm or a leg. The distant boats also form a single dark unit. A light slash here and there suggests the trim on the boat—and a dot represents a fisherman (notice especially the rowing figure to the center right of the detail).

Detail. You can see how the strokes were placed and left alone. Each stroke follows a part of the man's form. There are upright strokes along his back, diagonal strokes along his forearm and thigh, and vertical strokes for his lower leg. His rolled cuff is a simple slash, as is the dark opening of his unbuttoned coat. Here and there you can see spots where the canvas shows through. The scene was active and I had to work very quickly—I didn't have time to fill all the tooth.

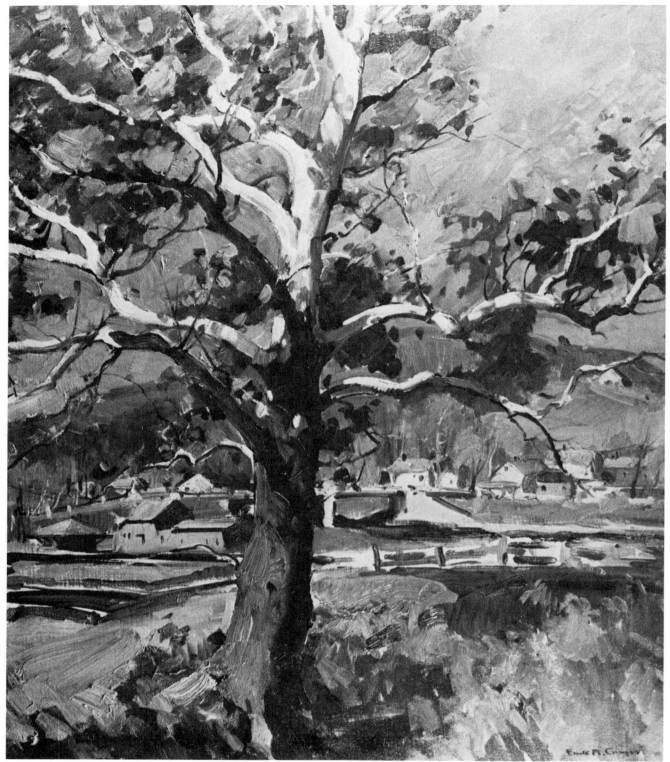

Sycamore, oil on canvas, 30″ x 36″ (76 x 91 cm.). Strong side lighting brought out the texture of the shirt and pants of the Cascais fisherman. Here it has a similar effect on the contrasting textures of the sycamore.

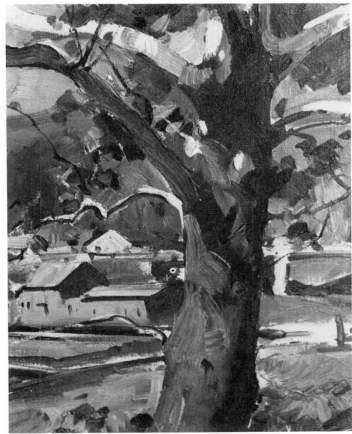

Detail (above). The same principle is at work in this detail. On the right the shadow is smoothly painted. As soon as the sycamore branch catches the light, however, the texture becomes more pronounced. Fluid strokes follow the direction of the light branch that runs across the center of the detail. Quick vertical strokes appear here and there; they suggest both peeling areas and the tension in the bark as the branch flares and connects to the tree. Among these large branches, there are many small, dark branches. Each is one stroke of the brush. Their delicacy accentuates the solidity of the rest of the tree.

Detail. The strength and breadth of the tree are suggested by broad vertical strokes — each stroke represents a different facet of the bark. Notice how the texture disappears as the tree goes into shadow. You can't see variations within the shadow. This smooth, simple area contrasts with and accentuates the rougher parts of the bark.

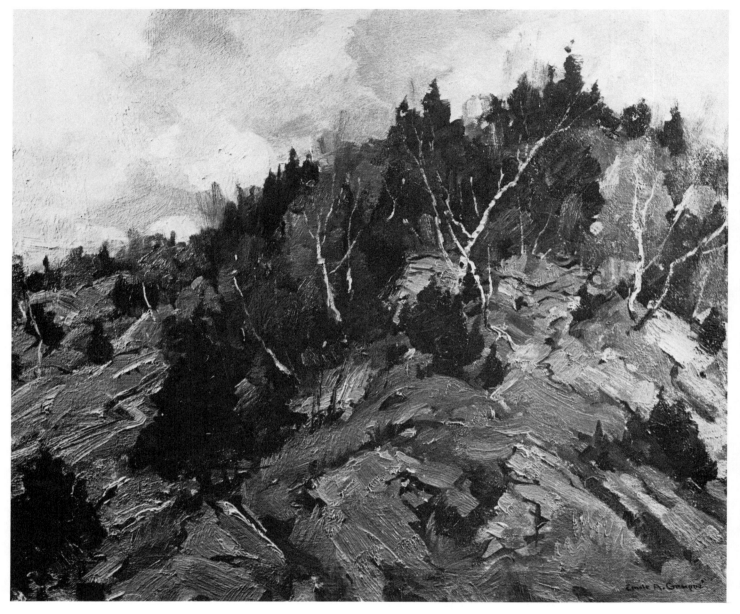

Rocky Hillside, oil on canvas, 25″ x 30″ (64 x 76 cm.). Let's end this section by looking at a gray-day picture. The glare in *The Inner Harbor,* page 136, reduced everything to simple masses, broken by calligraphic strokes. The gray day has a similar effect. The landscape again becomes a collection of big shapes. Against these shapes, thinner light and dark elements stand out clearly.

Detail (above). The mass of foreground rocks is composed of large, roughly textured strokes. Each stroke represents my impression of an individual outcropping. Once I've established the texture, I use a few darks—deep crevices in the rock—to cut the area to shape. Only a few such cracks are necessary: if you put in too many, you'll confuse the design and lose the spirit of your mass.

Detail. The same procedure is used in painting the trees. I look for areas of value—not for individual leaves. The background evergreens (dark masses) and fall foliage (lighter masses) are established first. I then place a few calligraphic lines against this simple background. The strokes describing the birches twist gracefully, thinning out as they get to the end of the small branches. This lyric movement contrasts effectively with the massiveness of the surrounding rocks and foliage.

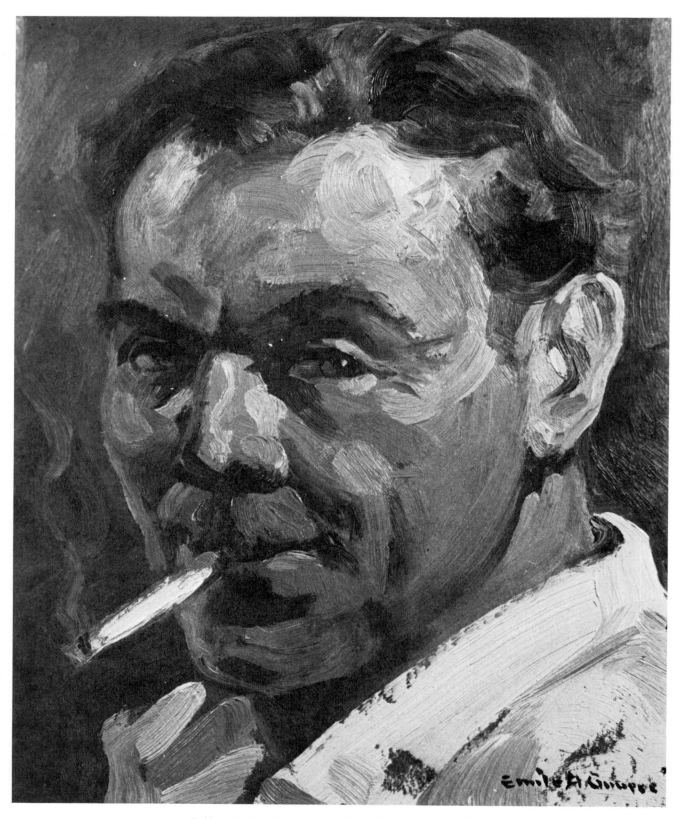

Self-portrait, *oil on canvas, 12" x 9" (31 x 23 cm.). To prove that I'm not joking when I tell you to try everything, I've decided to end this book of landscapes, seascapes, and harbor scenes with a self-portrait that I did some years back. It's painted like everything else in the book: individual strokes follow the construction of the ears, cheekbones, brows, and chin. Can you tell from the expression on my face that I expect you to take everything I say with a grain of salt? It's not gospel—it's just my opinion. And I'll be happy if even a fraction of it helps you.*

CONCLUSION

If you're smart, you'll most enjoy painting the things you know the least about—the things you always fail at. Those are the subjects that keep you from going stale. I knew painters in the old days who only did one picture—the picture the public wanted. They were hooked and spent their lives painting the same tree, the same wave, the same cows and sheep. But there's no fun when you paint like that. It's mechanical and monotonous labor. It's *work!*

When I was younger, I made a name painting nudes out-of-doors. They were sold almost before I finished them. But they were too popular—and I didn't want to spend the rest of my life painting figures. So I stopped. I knew another painter who was the rage of New York City fifty years ago. You *had* to have one of his landscapes—just to keep up with the Joneses. And he obliged by turning them out—ten at a time! He ended up with a chauffeur and a Locomobile; but today his pictures are worth only a tenth of what his patrons paid for them. They were what everyone wanted—but they weren't art.

So my closing advice to you is to paint what you like—don't worry if anyone else likes it or not. And study nature carefully, so you know what you're trying to do. Maybe you'll eventually agree with me: if there's a heaven, it must be here on earth. The world is so beautiful! Everyone subconsciously appreciates this beauty. But the painter's appreciation is more conscious—and he spends his life trying to communicate his feelings to others.

Try to do that in your own work. Paint different subjects and different moods. Do all things—but don't abuse any one of them. And be flattered if friends come into your place and ask "Did *you* do that?" Have a good time when you paint, and people will respond to your pictures. They know you work hard, but they'll also feel that you find painting *fun.* They'll sense that you're doing what you want to do—not what you have to do!

147

BIBLIOGRAPHY

Bates, Kenneth. *Robert Brackman, His Art and Teaching.* Noank, Connecticut: Noank Publishing Studio, 1951.

Bridgman, George. *Life Drawing.* New York: Dover Publications, 1961.

Carlson, John F. *Landscape Painting.* New York: Dover Publications, 1974. Above all, I recommend this book written by my principal instructor while I was a student at Woodstock. He taught me more than any other teacher in my life.

Gruppé, Emile A. *Gruppé on Painting.* New York: Watson-Guptill, 1976.

Hawthorne, Charles. *Hawthorne on Painting.* New York: Dover Publications, 1960.

Henri, Robert. *The Art Spirit.* Philadelphia: J. B. Lippencott Co., 1930.

Karolevitz, Robert. *The Prairie is My Garden, The Story of Harvey Dunn.* Aberdeen, South Dakota: North Plains Press, 1969.

Shaw-Sparrow, Walter. *Frank Brangwyn and His Work.* Boston: The Page Co., 1915.

INDEX

Edited by Connie Buckley
Designed by Robert Fillie
Set in 11 point Palatino by Gerard Associates Phototypesetting, Inc.
Printed and bound by Interstate Book Manufacturers